IMAGES
of America
CROATIANS OF CHICAGOLAND

ON THE COVER: Croatian immigrant John Majetić (white apron) stands in front of his John Majetich Saloon in 1903. Located at 8959 South Green Bay Avenue, he catered to the many Eastern European workers of the nearby South Works steel mill in South Chicago. His corner saloon was housed within the building of the Horvatsko-Slovenski Dom (Croatian-Slovenian Home). (Courtesy Chicago History Museum.)

IMAGES
of America

CROATIANS OF CHICAGOLAND

Maria Dugandžić-Pašić

Copyright © 2010 by Maria Dugandžić-Pašić
ISBN 978-0-7385-7819-4

Published by Arcadia Publishing
Charleston, South Carolina

Printed in the United States of America

Library of Congress Control Number: 2009941103

For all general information contact Arcadia Publishing at:
Telephone 843-853-2070
Fax 843-853-0044
E-mail sales@arcadiapublishing.com
For customer service and orders:
Toll-Free 1-888-313-2665

Visit us on the Internet at www.arcadiapublishing.com

In honor of my grandparents who, like many immigrants, tackled the challenges of surviving in a new country while teaching us the importance of cultural preservation, identity, and the meaning of family.

Contents

Preface		6
Acknowledgments		7
Introduction		8
1.	From the Shores of the Adriatic to Lake Michigan	11
2.	Ethnic Identity and Assimilation	23
3.	Patriotism and the Second Croatian Capital	55
4.	A New Era of Independence	103
5.	Croatians Today	115
Bibliography		127

Preface

Croatians have been drawn to Chicago in search of better opportunities since the late 1800s. Many of our ancestors arrived with literally "the clothes on their backs" and began working in the steel mills and factories. They were determined to build a better life for themselves and in turn had a part in building this wonderful city to help it become what it is today. Despite their initial poverty and the overall challenges of adapting to a new country, many managed not only to survive, but became successful and prominent citizens of this city. This book offers a unique window into their everyday lives and showcases personal stories of their American dream.

Our Croatian American community is proud of its politicians, judges, athletes, artists, broadcasters, celebrities, and other prominent professionals featured in this book who have roots in the Chicagoland area. Bridgeport native Michael Bilandić is among them and became the mayor of Chicago and an Illinois Supreme Court justice. Croatian native and NBA star Tony Kukoč enjoyed a successful career with the Chicago Bulls, and after retiring he decided to make Chicago his hometown.

Arguably the most visible contribution is that of Croatian artist Ivan Meštrović and his works *The Bowman* and *The Spearman*. These landmark towering sculptures have adorned the entrance of Chicago's Grant Park for more than 80 years. The renowned sculptor lived and worked in the Midwest and other parts of the country. We take pride that his works are displayed in various national museums and public spaces.

The consulate of the Republic of Croatia has witnessed important milestones for many of the groups featured in this book. Together we have proudly celebrated the 80th anniversary of Hrvatska Žena, the 75th anniversary of the Croatian American Radio Club, and the 35th anniversary of the Croatian Cultural Center. This year we commemorate the 20th anniversary of the Croatian American Association, a lobbying group, and soon we will celebrate the 100th anniversary of St. Jerome's Croatian Church.

The Republic of Croatia has established many external ties and has built a strong bond with the United States. We thank Chicago's Croatian community for helping us maintain these bonds and together build diplomatic, cultural, and social bridges over the years. We also thank the City of Chicago for its support of our people and its dedication to ethnic affairs. The many faces featured in this book are a testament to the determination of our people and their legacy as true ambassadors of their Croatian heritage.

—Renee Pea
Acting Consul General of Croatia in Chicago

Acknowledgments

For more than a century, thousands of Croatians and their descendents have contributed endless hours to help organize, educate, and preserve the traditions and faith of our community, and without their tireless efforts this book would not exist. With deep gratitude I thank the many who have opened up their treasure chests to piece together this chronology. Their personal stories and openness have shed much light on the journey of our predecessors.

In particular, I would like to thank the Croatian Ethnic Institute for collecting and preserving the largest collection of Croatian American archives in North America for the past 35 years. Special thanks to CEI director Fr. Ljubo Krasić for his willingness to help me and answer my endless inquiries day and night. Thanks also to Fr. Jozo Grbeš, Fr. Ivan Strmečki, Fr. Marko Puljić, Fr. Paul Maslač, Fr. Nikola Dugandžić, Fr. Ivica Majstorović, and Steffi Došen-Magnavite for helping me piece together years of events, names, and faces.

Endless thanks to the many organizations who have contributed information for this book: the parish clubs of St. Jerome's, Sacred Heart, Holy Trinity, and Croatian Catholic Mission Blessed Aloysius Stepinac; Croatian Woman; the Croatian Catholic Union; the Croatian Fraternal Union; the Croatian American Association; the Croatian Cultural Center; Dr. Ante Čuvalo; the many soccer clubs; Croatian-language schools and folklore groups of Chicago; and others documented within.

A warm thanks to Simon "Duško" Čondić for becoming my walking, talking archive machine. To the many who opened their doors, a special "*hvala*": Marie Lončar-Maras, Giggie Becich-Cortese, Eleanor Bozich-Grzetich, John Aranza, Nevenka Jurković, Ivan Mlinarich, Marija Fumić, Vera Starčević, Sandy Richo, and Antoinette Ptiček-DeWitt. I am indebted to Sanja Jurković-Budimir, Marko Puljić, Marija Kosić, Kata Vučić, Davorka Kirinčić, and Miki Vučić Tešija for helping in the editing process and piecing together the missing links.

Special thanks to Renee Pea, the acting consul general of the Republic of Croatia in Chicago, Danica Plazibat of the Ivan Mestrović Museums, the research staff at the Chicago History Museum, Rod Sellers of the Southeast Chicago Historical Society, and Melissa Basilone of Arcadia Publishing.

Lastly, special thanks to my husband, son, daughter, and family for their never-ending patience, encouragement, and support. It takes a village, and I'm thankful I have one. And to my late mother, a special acknowledgement for watching over me throughout this journey.

INTRODUCTION

It is the hope that the collection of photographs and stories featured in this book will rekindle similar accounts of survival, assimilation, and success for the many generations of Croatians living in the Chicagoland area. Ancestors in Croatia long lived under the foreign hand of ancient empires and dynasties. Geographically a strategic crossroads between Europe and the Middle East, the area has always been an important piece of real estate. As a result, struggles against foreign domination and the pursuit of religious freedom and ethnic identity have long been intertwined in the region's history and in the mentality of its people both yesterday and today. These predominant factors have carved out the path for many Croatian immigrants.

Since the 1400s through the 1800s, Croatian ships traveled from historic Adriatic ports in search of new trade opportunities in North and South America. While most of the ships carried adventurous sailors from the Dalmatian region, many were missionaries and merchants who settled along the coastal regions of the eastern and western edges of the American colonies. The first documented Croatian settler in the Midwest area was a priest from Zagreb, Fr. Joseph Kundek. He arrived in 1838 with the intent of establishing new missions in a predominately German-speaking Catholic diocese covering Indiana, parts of Illinois (including Chicago), as well as New Orleans and Pittsburgh. He is credited for establishing several cities, parishes, and schools in Indiana.

The dominance of Austro-Hungarian rule in the mid-1800s created cultural, economic, and political tensions for many Croatians. Savvy steamship and railroad agents combed southeastern European cities, heralding opportunity and success in the promised land. Inspired to leave, young sons, fathers, and husbands boarded these ships in hopes of finding better opportunities and greater freedoms. Thus began the first wave of migration.

The need for labor after the great Chicago fire of 1871 and the city's infrastructure build-up to the 1893 Columbian World's Fair lured many to Chicago as they entered American ports. The "City of Big Shoulders" was also enticing because of the well-known opportunities in the growing iron, rail, and food industries. Most of the early immigrants were male peasants with little or no education. A census taken in Croatia showed the literacy rate among men to be 23 percent in 1869 before increasing to 52 percent in 1900. Along with other Central and Eastern Europeans, the early Croatian settlers rolled up their sleeves to work at the nation's largest meatpacking houses in the Union Stock Yards, the mighty industrial plant at the McCormick Harvesting Machine Company, the railway giant United States Rolling Stock Company, and the Midwest powerhouse of U.S. Steel South Works. After earning money, some of the men returned back home to their families, while others stayed to build their future in the new land. It is estimated that nearly 400,000 Croatians entered the United States by 1914, with over 20,000 making Chicago their new home.

Saloons and boardinghouses served as the initial social centers. But by the early 1900s, community leaders took charge to assemble fraternal and social organizations and unite the nostalgic newcomers on a larger scale. New arrivals of clergy also helped the socialization process. Soon worshippers were able to attend Mass at the Slovenian-Croatian Catholic church of St.

George's on the South Side, The Assumption of the Blessed Virgin Mary in Englewood, the Greek-Catholic Eastern Rite church of Sts. Peter and Paul in the Little Village neighborhood, and the Slovenian-Croatian Catholic church of St. Joseph's in Joliet. Within 10 years, the community grew extensively and the need to expand was evident, prompting the formation of more churches: St. Jerome's in Bridgeport, Sacred Heart on the South Side, Holy Trinity in Pilsen, and St. Mary Nativity in Joliet. Later, in the 1970s, the Croatian Catholic Angel Guardian Mission, now the Croatian Catholic Mission Blessed Aloysius Stepinac, formed to serve those who lived on the city's North Side. These churches became social hubs for the community and today remain so.

Social halls, cultural, religious and political groups, radio programs, and sports clubs formed, adding a second layer of community support. Since 1893, Croatian music groups have entertained U.S. presidents, Chicago mayors, city officials, and the general population. In the early 1900s, there were at least five professional singing choirs, many of which performed at well-known Chicago venues.

The parades in the 1960s on State Street were a chance for Croats to exhibit their national costumes while expressing political support for American policies and passionate views about their homeland. Just as they did in the early days, religious holidays, cultural festivals, concerts, parades, and sports events remain a part of today's Croatian traditions in Chicago.

Politics for Croatian Americans has always been a balancing act of allegiance to two countries: staying committed and active with events in the homeland, while at the same time proudly participating in the American political process and way of life. The Croatian-language parishes did not address only faith, language, and solidarity, but they were also catalysts for adapting and including the immigrants into their new homeland and spreading American patriotism through their schools and parish societies. Over the years, thousands joined the U.S. Armed Forces, while others devoted their careers to public office. During the wars in Croatia and Bosnia-Herzegovina in the 1990s, Chicago became an epicenter for inspiration and leadership. Many Croatian Americans from Chicago supported independence for the Croatian people and in turn offered their professional services both domestically and in the region. Chicago organizations were tireless in their efforts to send financial and humanitarian aid to the war-torn regions.

It is difficult to determine the true numbers of Croatian descendents, because the early settlers were categorized as either Austro-Hungarians or Yugoslavs, but it is estimated that over 150,000 reside in the area today. The story of the Croatians of Chicagoland attempts to give a brief chronological snapshot, highlighting more than a century of history. While much has changed since the first settlers stepped foot in the "Windy City," the building blocks of Croatian heritage still exist. It is the author's hope that the ancestral traditions, patriotism, success stories, and legacies featured in this book will serve as an inspiration for more generations to come.

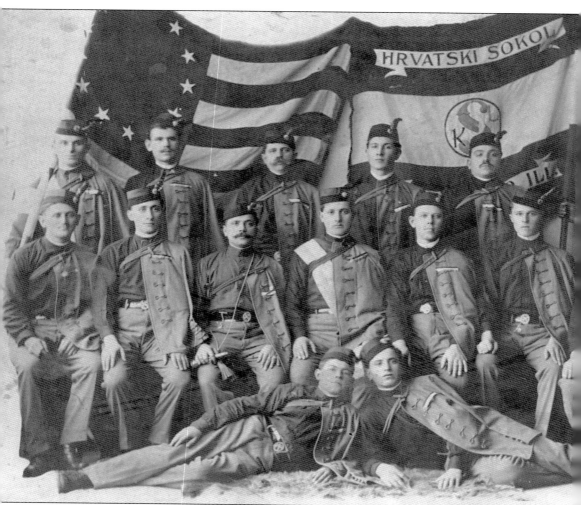

The first wave of Croatians who arrived in Chicago quickly realized the need to unite the community. One by one, various organizations formed, triggering a domino effect in major cities across North America. Soon Chicago became the leading epicenter for Croatian activity. Cultural groups, religious societies, fraternal unions, social clubs, and Croatian-language newspapers helped ease the sociocultural transition for many of these immigrants. They also helped bridge the nostalgia by preserving many traditions and values. The first Hrvatski Sokol (Croatian Falcon) of the United States was established in Chicago on August 28, 1908. Soon after, 12 other branches formed throughout the country. Dressed in their formal outfits here is the South Side Chicago Hrvatski Sokol group in 1924. (Courtesy Southeast Chicago Historical Society.)

One

FROM THE SHORES OF THE ADRIATIC TO LAKE MICHIGAN

Early records indicate that the first significant group of Croatians arrived to the shores of Lake Michigan around the 1870s; almost all were male with little or no education. The key to their survival was to "cluster" and "stick with their own," at first with their Slovenian counterparts but then later branching out to form their own groups. Initially boardinghouses and saloons served as the primary social haven for the new arrivals. By 1882, several Croatians even owned their own saloons. Most of the early settlers lived in and around the industrial areas of Chicago, joining the ethnic blocks around Packingtown–Back of the Yards, the lower West Side of Pilsen, Bridgeport–Armour Square, Englewood, Hyde Park and the South Shore areas of East Side, South Chicago, and Hegewisch.

By the early 1890s, a significant number of skilled professionals arrived. Witnessing the mass clusters of toiling laborers, crowded tenements, and fellow countrymen suffering nostalgia for their homeland, they quickly mobilized to organize social, humanitarian, and civic organizations. The need to communicate domestically and intercept news from abroad was crucial for this community. The first U.S.-based Croatian-language newspaper, *Hrvatska Zora* (Croatian Dawn), was published on August 4, 1892, by Janko Kovačević. Two months later, Nikola Polić began publishing a second newspaper, *Chicago*, with editorial direction from Zdravko Mužina. From politics to culture, Chicago quickly grew to become a central hub for the Croatian diaspora, prompting over 62 Croatian-language newspapers and periodicals to be published over the years.

Fr. Joseph Kundek was ordained in Zagreb. Inspired by Slovenian missionary Fr. Frederic Baraga's work with the Chippewa Indians, Kundek accepted a sponsorship by the Leopoldine Society of Vienna to promote missionary work among American German colonies. He arrived in southern Indiana in 1838 and used the society's funds to purchase 1,440 acres in Dubois County. He established the city of Ferdinand, in honor of Austrian emperor Ferdinand I and patron of the Leopoldine Society, and built the city's first church and school. His pastoral jurisdiction included the Chicagoland area. (Courtesy Croatian Ethnic Institute.)

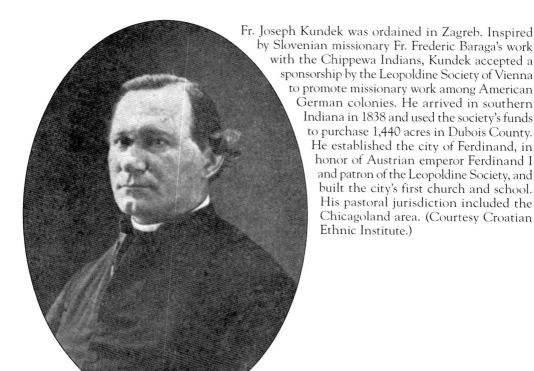

Riding on horseback in the region, Father Kundek's pastoral spirit inspired him to build more churches and schools and to establish other Indiana cities: St. Anthony, Celestine, Fulda, and Mariah Hill. The governor of Indiana proclaimed December 8, 1957, Father Kundek Day in order "to pay tribute to a great missionary, pioneer and citizen who left Croatia, the land he loved to come and colonize the wilderness of this great state, for which we owe him a huge debt of gratitude." (Courtesy Ferdinand Historical Society.)

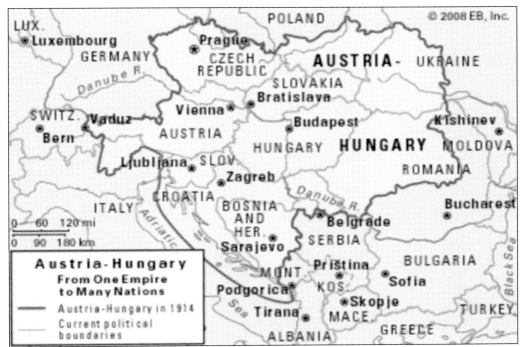

The Austro-Hungarian Empire ruled the region from 1867 to 1918. A map from 1914 shows the empire's eventual reach. By the mid-1800s, conditions for Croatians turned difficult. A dry soil spell, a coastal grapevine disease, the implementation of absolutism, and the loss of historical rights with the formation of the Austro-Hungarian Empire in 1867 triggered ethnic identity tension and job loss for farmers, winemakers, sailors, soldiers, and shippers. This became the catalyst for the first wave of Croatians to the United States. (Courtesy *Encyclopedia Britannica*.)

The first group of Croatians arrived in the 1870s: Ivan Božić from Jastrebarsko, Mijo Lukina and Mirko Cvetić from Plešivica, Stjepan Oborovečki from Zabok, Janko Krajačić from Žumberak, Stjepan Kesi from Dalmatia, and Ivan Randić from Boka Kotorska. Despite tensions over Austro-Hungarian allegiances, they managed to form the group Slavenska Sloga (Slavic Unity). Mato Depedar, seen here, helped form the Croatian Society of Illinois, Club Primorac, and the first Croatian orphanage in America. (Courtesy Croatian Ethnic Institute.)

The first group of settlers owned or operated 15 saloons in the downtown area. Others, mainly from the Hrvatsko Primorje region, assisted in the city's expansion by helping dig cable-car tracks and drainage canals. The saloons and boardinghouses, like Kompare's on the South Side, became the primary environment to exchange information about employment, housing, and news developments within the community or the homeland. Saloonkeepers and boardinghouse owners, in essence, were the ombudsmen and filled the gap of a community leader. (Courtesy Southeast Chicago Historical Society.)

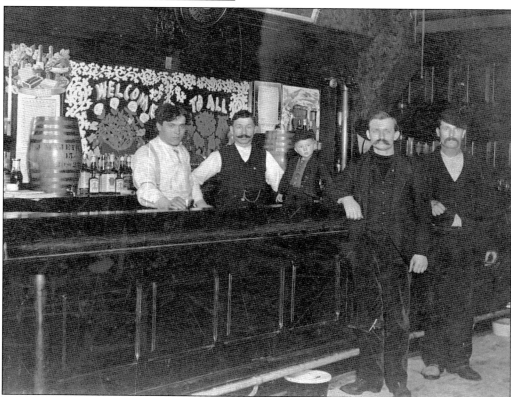

John Majetić bought his first saloon in the early 1900s at 8902 South Strand Avenue (later known as Avenue O). Like other immigrants, he used various spellings of his name, Majetish or Majetich, for easier English pronunciation. By 1903, he closed the first saloon and opened his second John Majetich Saloon on Eighty-fifth Street and Green Bay Avenue. Majetić, pictured here, stands with his white apron. His grandson Eugene Majetić is perched on the counter along with other patrons. (Courtesy Chicago History Museum.)

Andrija Janković left his hometown Sisak to join other laborers digging the Panama Canal in the early 1880s. In 1887, he came to Chicago and worked as a bartender and a travel agent. By 1910, having succeeded in establishing a bank, Janković formed the first Strossmayer Club in the United States in 1891. Named after Croatian bishop and politician Josip Juraj Strossmayer, the group met on Archer Avenue and worked hard to implement his ideas. (Courtesy Croatian Ethnic Institute.)

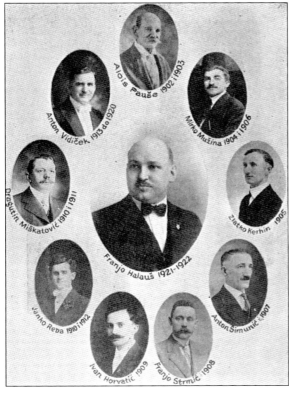

Janković helped form the first Croatian choir, Zora (the Dawn), in 1902. The group practiced in the Narodna Dvorana (the National Hall) in Pilsen. They performed at major Croatian events in Chicago and won acclaim when they traveled to Zagreb in 1911 to perform with other groups at the Croatian Singing Association. The chronology of Zora's leadership is shown here. He also helped form the group Hrvatska Sloga (Croatian Unity), which later joined the National Croatian Society. (Courtesy Croatian Ethnic Institute.)

```
Phone: Canal 3636

PRVA I NAJSTARIJA HR-
VATSKA TRGOVINA
Muških Potrebština
JURAJ MAMEK
1724 S. Racine Ave. cor. 18 St.
Chicago, Ill.

Preporuča braći Hrvatima svo-
je bogato skladište šešira,
rublja, kravata, donjega veša,
košulja, hlaća.
Na uvid stoje hiljade uzoraka
finoga sukna za odjela.
Primam narudžbe za izradbu
odjela po mjeri te jamčim za
solidnu izradbu
Hrvati poslužite se svojom
radnjom gdje ćete biti solidno
i u cijenama umjereno
posluženi.
```

Juraj Mamek arrived in 1893 from Karlovac. His previous experience as a tailor immediately landed him a job at an upscale shop on Michigan Avenue. Twelve years later, he opened up his own business in the Pilsen area and became the proprietor of the first Croatian tailor shop as this advertisement proclaims. (Courtesy Croatian Ethnic Institute.)

Mamek served as president of the Croatian National Society for six years. In 1903, during unrest in Croatia, he helped organize financial assistance for families of captured Croatian dissidents. This activity spurred the founding of Hrvatska Narodna Obrana (Croatian National Defender), which continued to aid families in the homeland. He was a trustee of the Croatian Credit Lending Association and the Slovenian Credit Lending Association Triglav. In 1910, he was selected by Chicago mayor Carter Harrison II to join the Chicago Plan Commission. (Courtesy Croatian Ethnic Institute.)

Tomo Lacković arrived from Plešivica in 1891. He soon realized the need to provide financial aid for the "little guy." On May 16, 1910, he called an informal meeting of fellow professionals to his home. They unanimously agreed to form the first Croatian lending institution and, within a month, gathered investors to divide 100 shares. Loans were primarily issued to assist the average working-class Croatian in the purchase or renovation of their home. (Courtesy Croatian Ethnic Institute.)

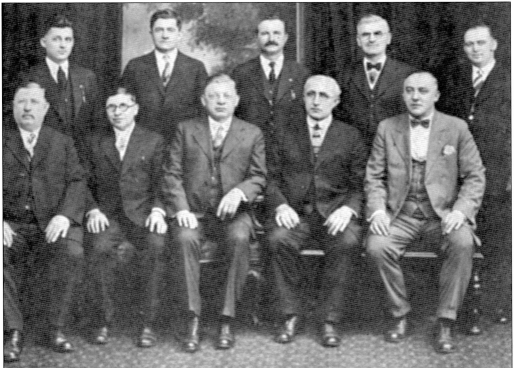

Over the years, Lacković led the group serving as president and treasurer. The main office was located in Lacković's office in Pilsen. Pictured here, in 1929, are some of the founding trustees of Hrvatska Pomoćnica (Croatian Building and Loan Association). From left to right are (first row) Tomo Lacković, Šimun Lacković, Juraj Mamek, Miko Starešinić, and Vinko Herceg; (second row) Mihael Juriček, Jakov Pavlečić, Mike Knafl, Josip Mlakar, and Vid Severin. (Courtesy Croatian Ethnic Institute.)

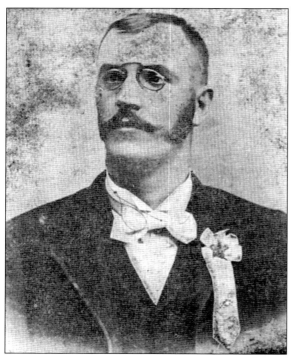

Zdravko Valentin Mužina left Croatia at the age of 25. He entered New York in 1892 as passenger No. 343, the same year Ellis Island was officially recognized as a federal immigration entry point. As a young newspaper publisher, Mužina headed for Chicago to establish a Croatian newspaper. His acquaintance Nikola Polić was already publishing the Croatian newspaper *Chicago* since October 1892. Mužina became an editor and stayed for over a year. (Courtesy Croatian Ethnic Institute.)

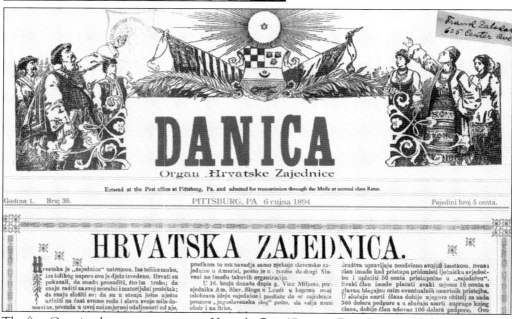

The first Croatian language newspaper, *Hrvatska Zora* (*Croatian Dawn*), was published in Chicago on August 4, 1892, by Janko Kovačević. After moving to Pittsburgh, Zdravko Valentin Mužina published his first Croatian newspaper, *Danica* (the Morning Star), pictured here. The newspaper changed hands several times since 1894 but eventually fell back into the hands of Chicago's Franciscan Press in 1945 and ultimately became the longest-running Croatian newspaper in the United States. (Courtesy Croatian Ethnic Institute.)

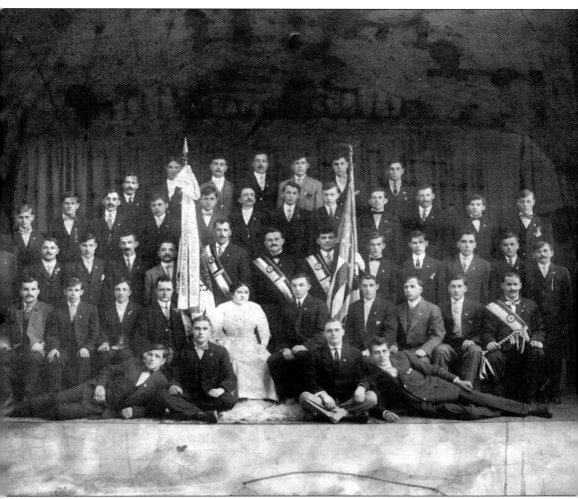

Mužina was passionate to organize help in mutual health and social care. While in Pittsburgh, Mužina, Petar Pavlinac, and Franjo Šepić formed the first fraternal society, Hrvatska Zajednica (Croatian Association), in 1894 and in 1897 changed its name to the National Croatian Society. Village loyalties, regional dialects, and provincial identities submerged into one slogan, "One for All—All for One." They organized English classes, encouraged members to become U.S. citizens, and provided insurance so desperately needed by workers toiling in America's most dangerous industries. By 1909, lodges sprouted and membership rates rose to over 20,000. Pictured here is the 1912 Hrvatski Sinovi (Croatian Sons), Lodge No. 15, Illinois. The union eventually changed its name to the Hrvatska Bratska Zajednica (Croatian Fraternal Union). A second union, the Hrvatska Katolička Zajednica (Croatian Catholic Union), formed in the early 1920s to offer similar benefits. The existence of these fraternal unions later played a key role to protect workers and their families during the union labor struggles and the Great Depression. Today the Croatian Catholic Union has merged with the Croatian Fraternal Union and together form the largest organization outside of Croatia. (Courtesy Croatian Fraternal Union.)

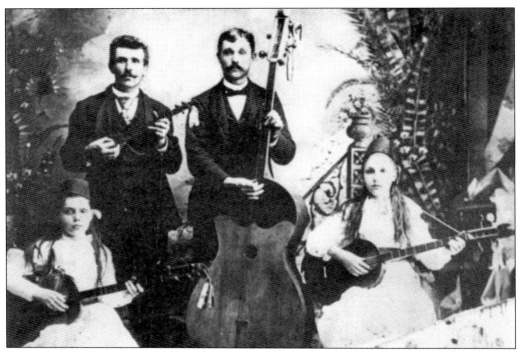

The tamburica instrument has long been part of Croatian song and dance. Legend has it that the first introduction of tambura-playing in the United States was a result of the handmade instruments crafted by Frank Hoffer in Pennsylvania. Born in Karlovac, he arrived in the United States in 1887. Hoffer is pictured here with this group—Mima Hoffer (left), Hoffer (second from left), Pavel Pavlinac, and Katica Hoffer—that performed at the 1893 Chicago World's Fair. (Courtesy Vladimir Novak.)

In the late 1800s, saloon listings outnumbered most other businesses in Chicago. In the downtown area alone, historians calculated there was one saloon for every 25 inhabitants. Most of the saloons offered free lunch. For 5¢, the customer could buy a drink and munch on typical offerings of fried sausage, pickled pigs' feet, baked beans, sauerkraut, pickled beets, and bread. The saltier the food, the more they drank, and the better it was for business. Shown here are some of the saloons listed in *Chicago's Directory* in 1895. (Author's collection.)

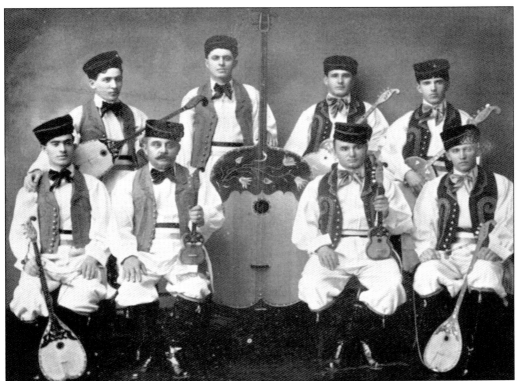

In 1906, the tamburica group Zvonimir formed in Pennsylvania. They embarked on a U.S. tour, entertaining immigrants from Oregon to Texas. The tour included a memorable performance for former U.S. president Taft at the Willard Hotel during the inauguration of President Wilson. In 1913, they reunited in Chicago, practicing in unused space at the publishing facilities of the Croatian newspaper *Hrvatska Zastava*. Chicago became their base as they went on to play internationally. The group disbanded in the late 1920s, but member Rudolf Crnkovich permanently settled in Chicago to start his own business as a leading U.S. publisher of tamburica sheet music. Pictured above are members from 1910. From left to right are (first row) Petar Savić, Rudolf Jambrešić, I. Kosić, and Janko Plasaj; (second row) Josip Mandle, Josip Žinić, Marko Podnar, and Vid Hribar. (Both courtesy Croatian Ethnic Institute.)

Trade Mark

RUD. CRNKOVIĆ

AMERIČKI IZDAVAČ TAMBU-RAŠKIH NOTA

Najbogatiji izbor svakovrsnih tamburaških nota u partiturama. Specijalitet u izdavanju Američkih i drugih novih komada savršenim tiskanim načinom U DIONICAMA (gotovo za svaku tamburu).

"TAMBURAŠKIH ŠKOLA", učila i ALBUMA za Solo Brač.

Skladište svije tamburaških potrebština. Cijenici na zahtjev.

Adresa: RUD. CRNKOVICH
2309 So. Leavitt St. Chicago, Ill.

(Sliku i biografiju vidite na strani 91)

TAMBURITZA MFG. CO.

Najpoznatija i najveća tvornica tambura te svih žičnih instrumenata u Americi. Priznati rad i točna posluga preko 25 godina.
Pišite po nove cjenike.
Imade na zalihi svih nota.

IVAN J. HLAD
1707 S. RACINE AVE., CHICAGO
Phone CANal 4708

Ivan Hlad was born in Hrvatsko Zagorje. His interest in the art of instrument-making took him to Zagreb and then Graz, Austria. In 1912, he arrived in Chicago. At the time, the Groeshl Music Company, which had been in business since 1890, was the lead musical instrument–maker in Chicago and had expanded their inventory to include the tamburica family. By 1917, Hlad, pictured below, had saved enough money to open up his own factory, the Tamburitza Manufacturing Company. (Courtesy Croatian Ethnic Institute.)

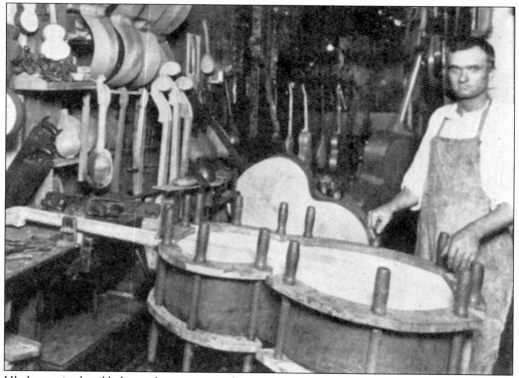

Hlad organized and led a tamburica group, playing at picnics, weddings, and other social occasions. In 1933, Hlad's set of farkas instruments were displayed at the World's Fair in Chicago. Later his grandson took over the family business and it was renamed the Balkan Music Company. Many in the community today still own instruments made by Ivan Hlad. (Courtesy Vladimir Novak.)

Two

ETHNIC IDENTITY AND ASSIMILATION

Croatians were predominately influenced by the Roman Catholic Church, thus religion essentially demarcated the geographical zones for the community. By the early 1900s, six parishes were founded in and around Chicago's ethnic and industrial areas. The first, the Assumption of the Blessed Virgin Mary, was formed in 1900 in Englewood. In 1905, Sts. Peter and Paul served worshippers of the Eastern Rite Catholic Žumberak Colony who had settled in the Little Village area. The Wentworth Colony, mostly Dalmatians, settled in Bridgeport–Armour Square and built St. Jerome's Croatian Church. The West Colony, many from Zagorje, settled in Pilsen and worshipped at Holy Trinity Croatian Church. The South Colony settled in the southern industrial districts and built Sacred Heart Croatian Church.

A significant Croatian population lived outside the Chicagoland area. Together with Slovenian Catholics, they celebrated Mass at St. Joseph's Parish in southwest Joliet, and soon after the Croatian parish of St. Mary Nativity was founded. In northern Indiana, the large industrial workforce prompted several locations for Croatians to gather: Holy Trinity in East Chicago, St. Joseph's in Gary, and Sts. Peter and Paul in Whiting. Combined, these churches became the community's social epicenter. They also provided a base for ethnic identity through the formation of many church societies, singing groups, and other organizations.

Assimilation into the American way of life was the second phase for the early settlers. Parishes expanded and built English-language elementary schools. Taverns, funeral parlors, mortgage companies, and drugstores sprouted in the Croatian zones, offering services with old-country style. Croatian doctors and dentists built offices within walking distance to their communities. Many changed their names for easier English pronunciation. Artists and athletes slowly began to extend beyond the ethnic boundaries to showcase their talent in non-Croatian venues. Like other Chicagoans, Croatians gradually became a part of the world around them, which included World Fairs, presidential elections, labor disputes, the Prohibition controversies, and the suffering through the Great Depression.

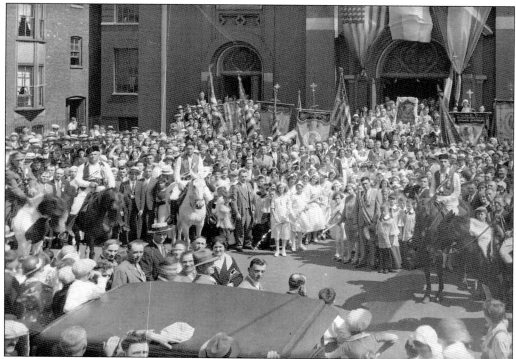

St. Jerome's Croatian Church was established in 1912 by Fr. Leon Medić and grew to have the largest school in a U.S. Croatian parish by 1926. The location changed twice before the site of today's parish on Twenty-eighth Street and Princeton Avenue was selected in 1922. Dubbed Mala Dalmacija (Little Dalmatia), the predominately Dalmatian congregation was the home of many religious societies in the early 1900s. As represented above in the late 1920s with their many banners, these same societies have consistently participated in the annual St. Jerome's Velika Gospa (Feast of the Assumption of the Blessed Virgin Mary) procession held every August 15 to commemorate the holy day. Pictured below in 1948 are members of the Benevolent the Benevolent Society of St. George, the Patron of Poljica. The group was established in 1913 and marched in St. Jerome's first Velika Gospa procession the same year. (Both courtesy St. Jerome's Church.)

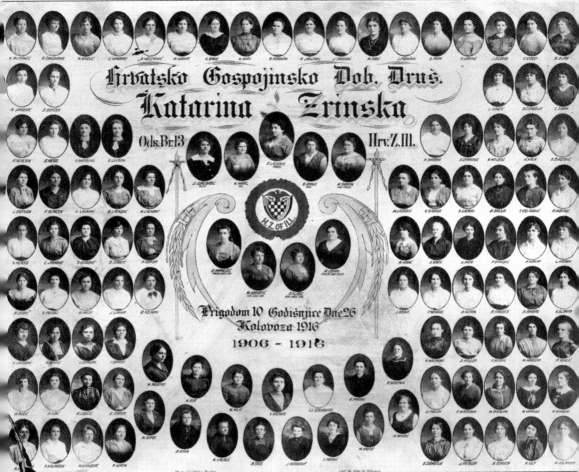

Church groups sprouted from every corner of Chicago in the early 1900s. Pictured here are members of the Hrvatsko Gospojinsko Dobrotvorno Društvo Katarina Zrinski (Croatian Ladies Charitable Club Katarina Zrinska). Established in 1906, the group posed here for their 10th anniversary in 1916. The club was named after Croatian noblewoman Ana Katarina Zrinski (née Frankopan). In 1671, her husband, Petar Zrinski, and her brother, nobleman Fran Krsto Frankopan, were executed after their ruler, King Leopold I of the Hapsburg Family, uncovered their plot for an uprising. Katarina was forced into seclusion and died with her two daughters in a Dominican convent. Her legacy as a Croatian historian, devout Catholic, and volunteer inspired many women, thus the first Katarina Zrinski Clubs began in the United States. (Courtesy Croatian Ethnic Institute.)

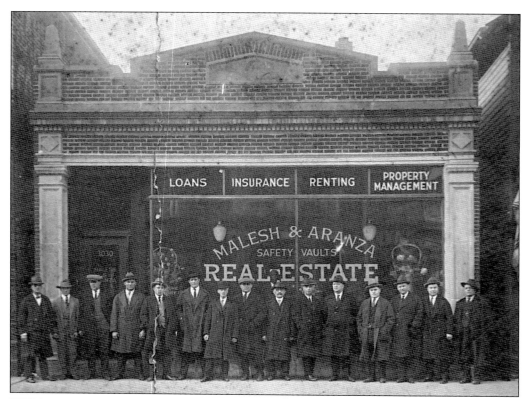

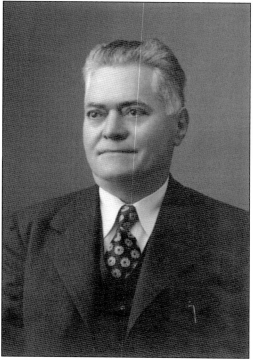

John "Duje" Aranza arrived in Chicago in 1906 from Kaštel Novi. He became a prominent businessman in the Bridgeport–Armour Square community. Pictured above in 1924, Aranza (fourth from right) stands next to his business partner Tom Malesh (to the right of Aranza) and their friends for the grand opening of their office at 3030 Wentworth Avenue. He sold steamship tickets through the Cunard Company to help immigrants travel from Croatia to Chicago and served as the local notary, real estate agent, and mortgage broker. He helped fellow Croatians expedite legal services such as *punomoć* (power of attorney) and married couples by proxy so they could be reunited in the United States. Pictured at left in the late 1940s, Aranza serviced residents of the community up until his death in 1962. His widow, Anna, and their son John ran the business until 1990. To this day, their son still services some of his father's clients. (Both courtesy John Aranza.)

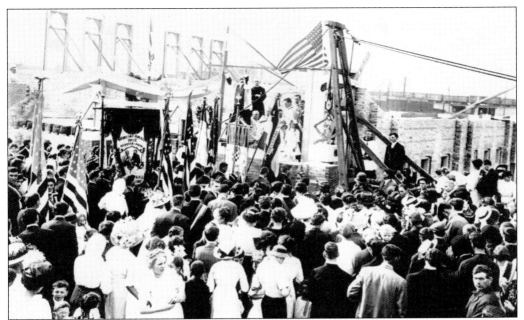

Since 1904, Croatians on the South Side worshipped first at St. George, a Slovenian-Croatian Catholic church. Tensions grew between the two communities, and eventually the Croatians built their own church on Escanaba Avenue and Ninety-sixth Street. Fr. Ivan Stipanović, pictured here, celebrated the first construction of Sacred Heart Church in 1913. Alongside the School of Sisters of St. Francis, a grade school and social hall were eventually built and are still in use today. (Courtesy Southeast Chicago Historical Society.)

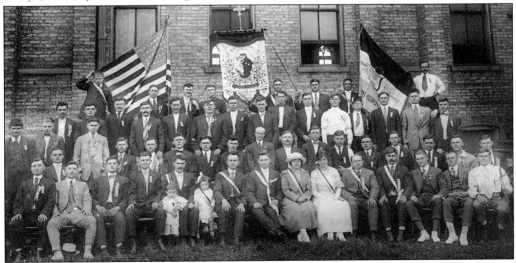

The Herzegovinian Croatian Charitable Club of St. Anthony of South Chicago was established in 1917. Andrija Hrkać, one of the founders pictured here, left Široki Brijeg in 1911 for Canada. During World War I, the Canadian government was placing Austro-Hungarian citizens in internment camps. To avoid the camp, Hrkać and two fellow Croatians built a raft and rowed across Lake Superior to the United States. He arrived in Chicago around 1916 and opened up a boardinghouse and saloon on the South Side. (Courtesy Croatian Ethnic Institute.)

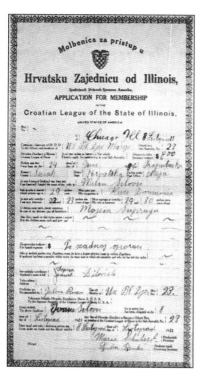

The Hrvatska Zajednica Illinois (Croatian League of Illinois), formed in 1905, offered life insurance and promoted cultural and social preservation to 250 groups. In 1911, Milan Silović paid $8 for his membership as shown here. By 1925, the league had 14,660 members and annual revenues of over $500,000. They became the second-largest Croatian humanitarian organization in the United States. In 1926, they merged with the Narodna Hrvatska Zajednica (National Croatian Society) of Pittsburgh and the Croatian beneficial society group Sveti Josip of Kansas City to form the Hrvatska Bratska Zajednica (Croatian Fraternal Union). (Courtesy Vladimir Novak.)

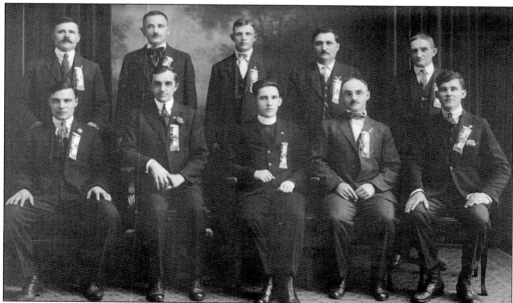

A second benevolent organization, the Croatian Catholic Union (CCU), was established in 1921 in Gary, Indiana. Within five years, it had 24 lodges in Chicago. The organization also offered mutual assistance for Croatians and encouraged spiritual, cultural, and charitable participation. The first board of directors are, from left to right, (first row) Grga Rakić, George Ramuščak, Rev. Dragutin Jesih, Gaspar Puralić (founder), and Ivan Galić; (second row) Nikola Prahovich, George Garcina, Ivan Kupres, Petar Galović, and Lovro Mikan. (Courtesy Croatian Ethnic Institute.)

At the age of 17, Marin Pleština left his hometown of Klis to board the SS *Erny* in Trieste that was bound for New York. He arrived in Chicago in October 1905 and joined the Dalmatinski Hrvatski Sokol (Dalmatian Croatian Falcon Club). Wrestling was a popular sport at the time among ethnic groups and a symbol of power. The Sokol group realized Marin's physical assets and encouraged him to compete. He won his first wrestling competition against Danish champion Paul Martis and, after that, went on to beat Jack Taylor at Madison Square Garden and longtime Polish champion Stanislaus Zbyszko. He trained at the Chicago Athletic Club. Pictured (standing) at right in 1922, he and wrestler Ivan Ivkovitch demonstrate an arm hold. The cartoon below shows a worried American wrestling industry doing their best to avoid meeting the Croatian wrestler in the ring. (At right, courtesy Chicago History Museum; below, Croatian Ethnic Institute.)

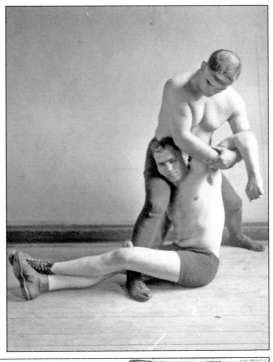

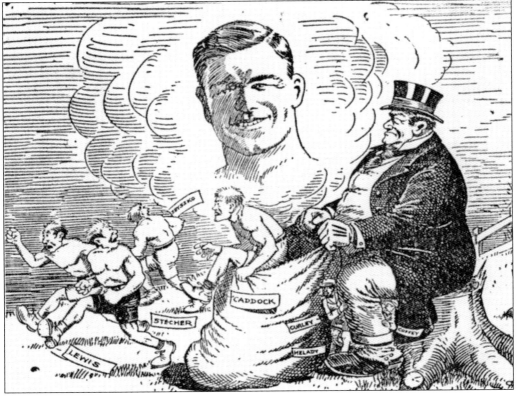

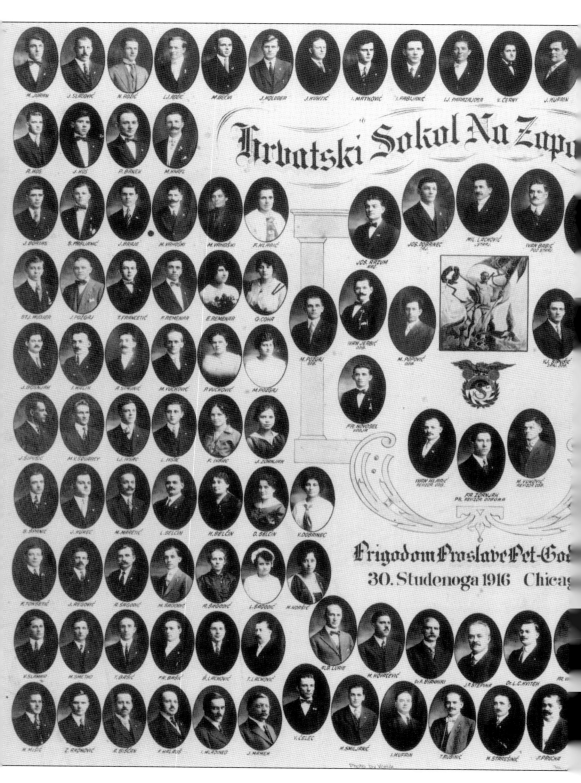

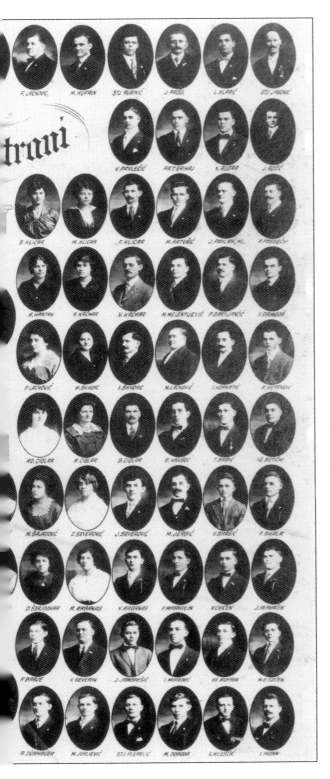

In 1916, a group of Croatians purchased a building in Pilsen for $20,000 at 1903 Racine Avenue, only a few blocks from Holy Trinity Church. A tavern occupied part of the space, while the rest was converted into the Hrvatski Narodni i Sokolski Dom (Home of the Croatian Hall and Falcon Club). Inspired by the Czech Sokol movement, the Croatians, like other Slavs, tapped into the Sokol ideology to promote physical, moral, cultural, and intellectual training for all social classes. They held social events in the basement and club meetings on the first floor. Pictured are over 150 men and women honoring the fifth anniversary of the Hrvatski Sokol na Zapadnoj Strani (Croatian Falcons of the West Side). The building still stands and bears an inscription on the cement awning. (Courtesy Holy Trinity Church.)

While the faces seen here are unknown, the stories are surely similar. One such story is that of Ilija Zorich, who arrived from Grude around 1912 to join other immigrants toiling in the steel mills of northern Indiana. A bachelor, like most of the workers, Ilija grew nostalgic. He never forgot Anica, the cute girl he said goodbye to on the dirt road back home. He sent a letter to her father asking for her hand in marriage. Soon after, Anica Peneva arrived in Chicago. (Courtesy Southeast Historical Society.)

The Zorichs first attended Sts. Peter and Paul Croatian Church in Whiting, Indiana, but soon after enrolled their children at Sacred Heart School. In 1925, Zorich built his first building by hand, shown here, on the corners of 135th Street, Brandon Avenue, and Brainard Avenue. He initially leased out the space but from 1933 to 1948 opened his Eli's Triangle Hotel and Lounge, servicing the many workers of the nearby mills. The building still stands. (Courtesy Ilija Zorich Family.)

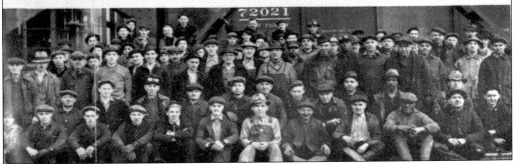

J-4-E blast furnaces, *South Works*. Sitting, first row, left to right: W. Pilewski, P. Maggio, ... Drew, E. Stack, J. Kreczmer, J. Kowalski, A. Zigante, Ivan Ladischek, W. Wisher, J. Clemons, M. Gasparach. Second row, left to right: A. Kisials, Geo. Sloan, Jr., Geo. Lotz, J. Shatkowski, J. Lopez, F. Mieszkowski, H. Wojciechowski, O. Piel, A. Sihocky, W. Crawford, J. Mazur, S. Macink. Standing, first row, left to right: T. Wisniewski, R. Draper, M. Johnson, C. Hocberg, J. Dewar, Wm. Nordengreen, C. Olson, W. Duzynski K. Boatman, M. Kozul, V. Dragosavac, S. Renko. Second row, left to right: *Cannot identify*, Ed. Rembiakowski, E. Knoll, M. Rehak, A. Johnson, M. Lindahl, H. Dowdell, W. Green, P. Presg..., R. Benjamin, A. Lestinski. Third row, left to right: J. Kovalcin, A. Mansfield, Jr., E. Flanagan, R. Martinez, S. Diern..eld, A. Swarchek, A. Struck, M. Vurdela, M. Frain, N. Ciganovich, V. Negomier, J. Narantich, M. Kolar. Fourth row, left to right: *Cannot identify*, R. Marschke, B. Holman, J. Chorak, *cannot identify*, H. Blaszczyk, D. Zeiring, E. Wolff, L. Armstrong, G. Kaleck, F. Murphy. Fifth row, left to right: J. Kelly, *cannot identify*, H. Chojnacki, G. Carey, H. Zeisel, M. Martis, H. Plucinski, N. Blanko, *cannot identify*, E. Brown, L. Washington, E. Marschke, *cannot identify*, E. Gilfeather.

Chicago grew from one million people in 1880 to over two million by 1910. By then, over 70 percent of all immigrants in Illinois were living in Chicago and Cook County, where unskilled industrial jobs could be found. But with these jobs came low wages, unstable employment, and unsafe and poor working conditions, all of which helped motivate the community to form benevolent societies to protect their fellow countrymen. Several Croatians, pictured here, worked at the U.S. Steel South Works in South Chicago. (Courtesy Southeast Chicago Historical Society.)

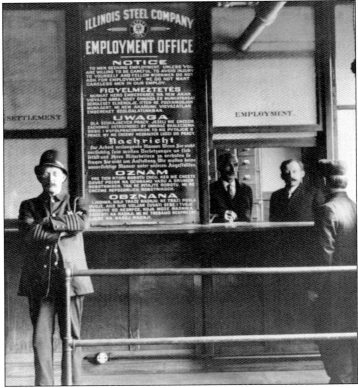

In 1900, seven of the country's twenty-two industrial plants were based in Chicago. By 1903, an average workweek for the industrial laborer was about 60 to 80 hours at about 22¢ an hour. Employment offices, like the one here, adapted to service the large non–English speaking workforce. Predominately single males, these immigrants stayed at boardinghouses or tenement buildings. Often these conditions were fatal breeding grounds for tuberculosis, typhoid, and diphtheria outbreaks. With no family around or formal insurance, many died alone. (Courtesy Southeast Chicago Historical Society.)

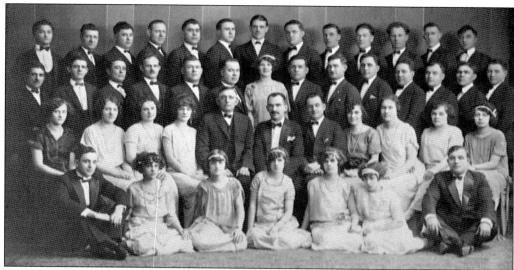

The Hrvatsko Pjevačko i Dramatsko Društvo Jadran (Croatian Choir and Drama Club Jadran) was formed in 1924. It performed *Momci na Brod*, an operetta by Croatian composer Ivan Zajc, which spurred considerable interest even with the American public. Many of the members were common laborers with no previous formal training. Pictured above in the center back row is Joseph Pavelin, who lived to be over 100 years old and also became the oldest hourly paid employee of the Ford motor plant on Torrence Avenue. Below, on the left, Jadran singer Anna Billich-Aranza (far right) sits on the bumper with her brother John and friend Miss Saso. Anna's father, Duje, came to the United States in the 1900s and helped build the original Chicago Stadium, now the United Center. (Both courtesy John Aranza.)

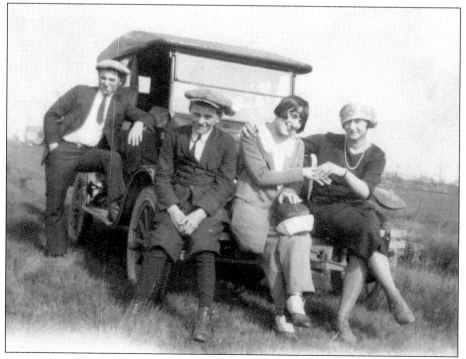

Holy Trinity Croatian Church was founded by Rev. Josip Sorić. His first Mass was celebrated on Christmas day in 1914. In 1921, George Cardinal Mundelein, archbishop of Chicago, asked the Dominicans to take over responsibility for the parish. Fr. Inocent Bojanić arrived on February 4, 1922, the first Dominican to take up permanent residence in the Archdiocese. Father Bojanić served as pastor of Holy Trinity for 44 years. Pictured is parishioner Mary Blašić at her First Holy Communion in 1925. (Courtesy Sandy Richo.)

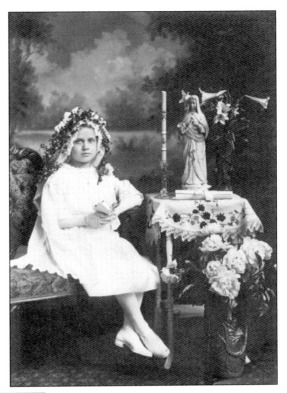

Stjepan Širanović and his wife, Barbera (née Pavlović), arrived in the 1900s from Međimurje. They are seen here with their first two children, Anna and Franjo (Frank). For years, they lived next door to Holy Trinity Church and helped out as the official caretakers of the premises. They later moved down a few blocks to 1820 South Throop Street when the church expanded to make room for the school. (Courtesy Sandy Richo.)

While many Croatians settled in Chicago, others continued southwest to Joliet. Mate Mikuličić arrived from Krasica, Croatia, at the age of 17 in 1893. He worked at the U.S. Steel mill in Joliet and lived with seven other Croatian men at the boardinghouse of John Jerola. In October of 1896, Mate became a naturalized U.S. citizen. He married Marija Juričić in 1903, and together they raised eight children. (Courtesy Mate Mikuličić Family.)

St. Mary Nativity Church in Joliet was established for the Croatian community in 1906 by Fr. George Violić. Before St. Mary's, Croatian families attended St. Joseph's Church together with Catholic Slovenian families. Mikuličić was a founding member and helped his community by sponsoring and providing funds for fellow countrymen coming to the United States. He helped establish the Croatian Men's Club in Joliet and is pictured here (back row, third from left) with the group around 1910 (back row, third left). (Courtesy Mate Mikuličić Family.)

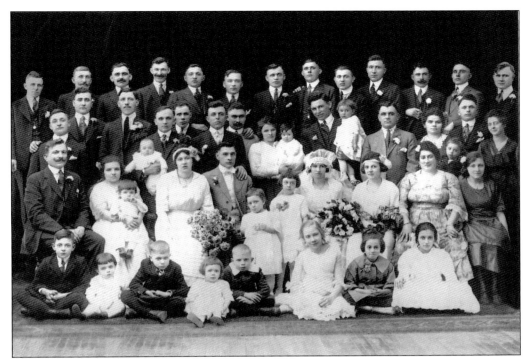

Marko Čondić arrived from Imotski in 1912. He worked at People's Gas and Coke Company on Thirty-first Street and Pitney Court for 19 years. Single women were scarce in the community, so Marko wrote to his old employer in Omiš asking for his daughter's hand in marriage. The father refused three times until his wife persuaded him. Married by proxy in Croatia, Tona and Marko celebrated their marriage (above) at the German Hall in what is today the Chinese Christian Union Church. The couple had eight children. From left to right, their sons (right) Marko Jr., Ivan, and Jozo pose for the camera. Marko was short just one year to receive his pension when he died in 1935. His widow was left to tend to the children alone, surviving on $75 a month from government relief. (Both courtesy Simon Duško Čondić.)

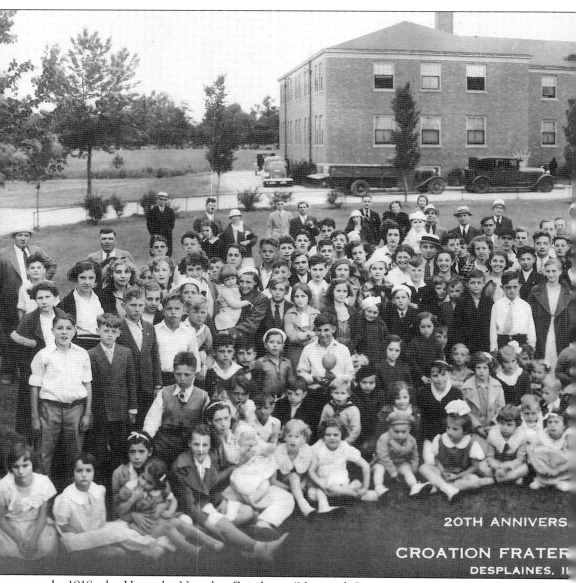

In 1918, the Hrvatska Narodna Zajedinca (National Croatian Society, or NCS) agreed to establish an orphanage to assist children of deceased members. The society purchased land in Des Plaines and opened the first U.S. Croatian Orphanage. By 1919, over 531 NCS members had died of influenza; thus, the children were sent there. The orphanage later became the Children's Home of the Croatian Fraternal Union. The group poses here for the 20th anniversary in 1936. Well-known tambura player John Gornick was sent there to live in the 1940s. Although these

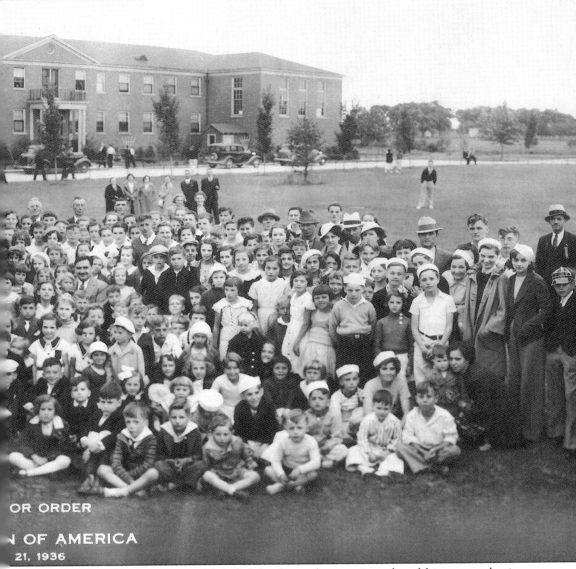

traumatic circumstances impacted John's life, the orphanage introduced him to tamburica music. Since then, he has donated countless hours of his time to teach young tambura players, including all six of his children, and was later inducted into the national Tamburica Hall of Fame. As he has in the last 20 years, Gornick continues to serve as the director of the Prijatelji Tamburica Orchestra of Chicago. The orphanage closed in 1967 and the property was sold. (Courtesy Croatian Fraternal Union.)

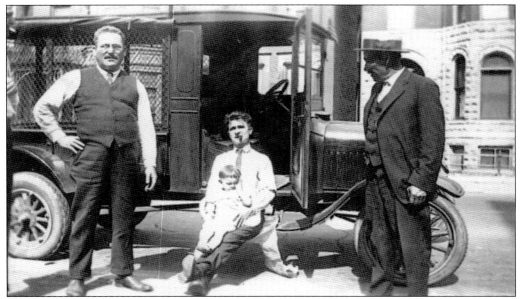

Petar Aljinovich worked as a butcher for Sam Serapino in the Bridgeport area. With his daughter Vinka on his lap, he poses with his friends Ivan "Vuk" Lisica (left) and Bridgeport bakery owner Mate Šaškor in 1924. At the time, the wire mesh was needed on the Ford Model A delivery truck to prevent theft from the back bed. (Courtesy Giggie Becich-Cortese.)

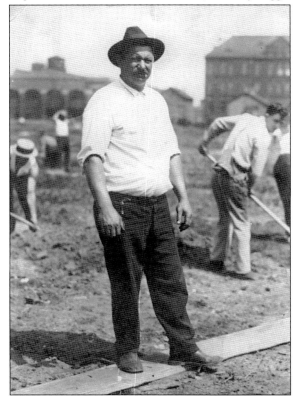

Filip Alujević was born in 1879. He arrived from Split in 1910 and then sent for his wife, Marija (née Vrdoljak), and son to join him a few years later. The family lived on Wentworth Avenue and eventually shortened their name to Alvić. Standing over six feet tall, Filip Alvić easily found work at Chicago's construction sites and was quickly promoted as supervisor for the many Croatian laborers. Pictured here, he joins in the digging of the first buildings on Lake Shore's North Side. (Courtesy the Alvić family.)

The Croatian parishes, and especially the Croatian Franciscan Monastery in Chicago, invested enormous efforts caring for the admission and acceptance of the new immigrants, obtaining employment for them and introducing them to the American way of life. Pictured is a group of Franciscan priests in 1935 planning further development of the Croatian Commissariat. From left to right they are Fr. Špiro Andrijanić, Fr. David Zrno, Fr. M. Faust, Fr. Blaž Jerković, and Fr. Zvonko Manduric. (Courtesy Croatian Ethnic Institute.)

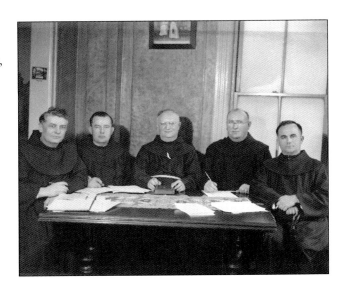

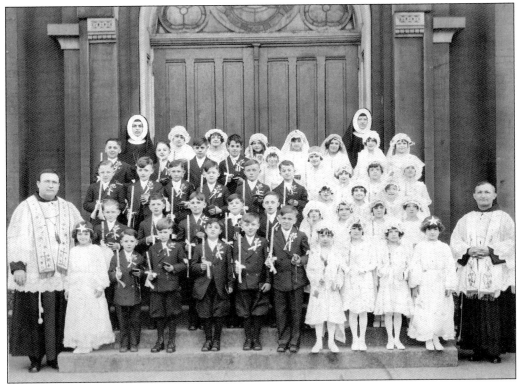

Little Nick Bozich stands with his fellow classmates as they pose for their First Holy Communion picture on the steps of St. Jerome's parish in the 1930s; Fr. Blaž Jerković stands on the left. The nun's traditional white collar is a symbol that the nun is surrounded with "community," the religious life lived in common. (Courtesy Eleanor Bozich-Grzetich.)

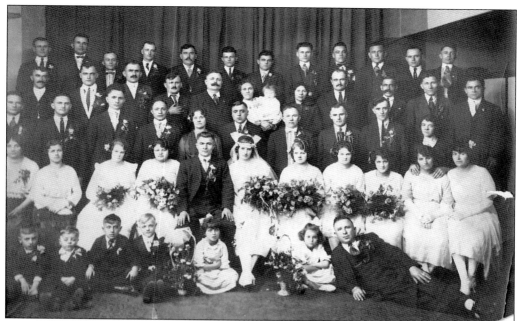

Marko Lončar arrived in Chicago in 1918. He met his future wife, Kata Stanković, after buying her an ice cream after an English class at Sacred Heart Church. Pictured here at their wedding in 1923 are Ivica Kožul (third row, third from the left) and his wife (second row, third from left), Milan Stanković (third row, fourth from left), Jure and Dragica Stanković (behind the bride and groom), and tavern owner Frank Martinović (lying down in the first row). Marko and Kata had four children: Marija, John, Robert, and Marko Jr. (Courtesy Bob Lončar and Maria Lončar-Maras.)

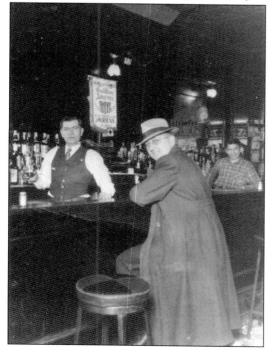

Lončar opened Marko's Café in 1924 on 3201 East Ninety-second Street. Pictured here in 1942, he stands behind the counter with his son Bob to the right. After his death, his wife, Kata, and sons took over the family business up until 2005. The café remained open despite the many economic and social changes in the neighborhood. For decades, his brother Radovan "Fred" also owned Fred's Tavern in South Chicago. (Courtesy Bob Lončar and Maria Lončar-Maras.)

Pictured here are the wives of some of the South Side tavern owners, Mary Cholak (left), Mary Soldo (center), and Kata Lončar. Always together, this group was known as the three musketeers of the neighborhood. During the Prohibition, it was well known that many Croatian tavern owners would make moonshine and send their wives to Calumet Park Beach to sell it from their undercover baby buggies. (Courtesy Bob Lončar and Maria Lončar-Maras.)

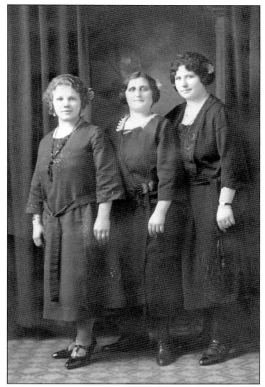

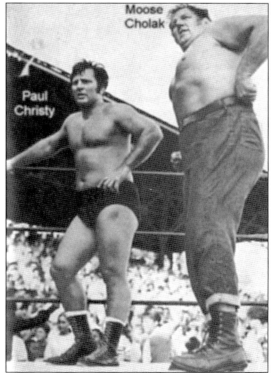

Born to Steve and Mary Cholak, Edward "Moose" Cholak became a wrestling fixture, standing over six feet tall and weighing over 360 pounds. For 40 years, he competed in over 8,000 matches, becoming world champion in 1963. He worked for the City of Chicago as an engineer from 1976 to 1996, and when he was not wrestling, he worked nights and weekends at the family bar The Calumet Beach Inn Tavern on the Southeast Side until he sold it in 1980. (Courtesy Croatian Ethnic Institute.)

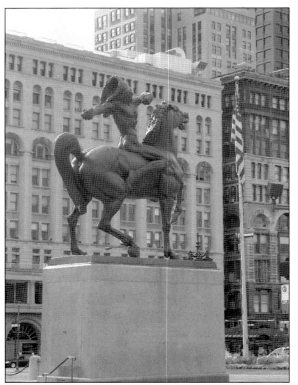

The bronze Indians *The Bowman* and *The Spearman* (left) have stood guard over Chicago's Grant Park's entrance on Congress Parkway for over 80 years. Croatian artist Ivan Meštrović erected the Native American Indians in October of 1928. From 1924 to 1926, Meštrović had a series of exhibitions in the United States, including Chicago. This exposure helped in the eventual commissioning of the Indians from an endowment established by Chicago lumber magnate Benjamin Franklin Ferguson, who left $1 million to provide the city with public sculptures. Managed and commissioned by the Art Institute of Chicago, a 1926 contract with Meštrović called for the artist to be paid $150,000 to design and deliver the Indians in two years. The designs and plaster molds were cast and shipped from his studio in Zagreb (below) from 1926 to 1927. (At left, author's collection; below, courtesy Ivan Meštrović Museums and the Ivan Meštrović family.)

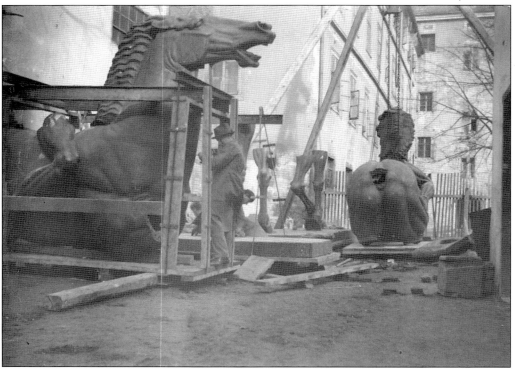

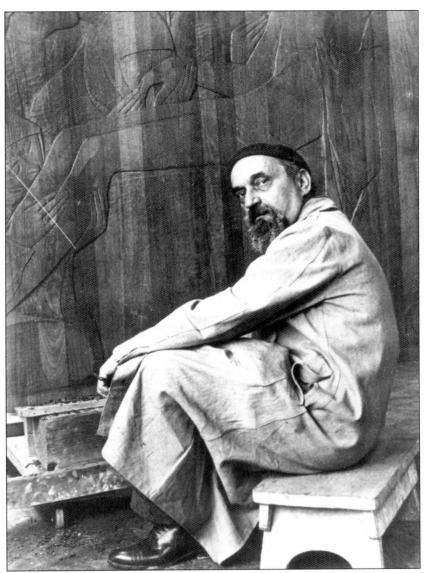

Born in the Dalmatian region of Croatia, Ivan Meštrović lived and worked in Europe and outside the United States since 1947. He moved to the United States to teach at Syracuse University. In 1953, he was awarded the American Academy of Arts and Letters' Gold Medal and was the first to have a solo exhibition at the Metropolitan Museum of Art in New York City. His work and reputation had become so prestigious that when Meštrović, along with 50 other prominent "persons of the year" took American citizenship in 1954, Pres. Dwight D. Eisenhower personally presided over the ceremony. A significant collection of Meštrović's work is displayed at the Notre Dame University Museum, where the artist taught and sculpted for the last seven years of his life. Other examples of Meštrović's work are housed in various churches and public spaces throughout the United States, including the Chicago Art Institute's Ryerson Library, Syracuse University, and the Arts and Science Center in Baton Rouge, Louisiana. He is pictured here in 1958 prior to finishing his relief *Polaganje u Grob* (Placing in the Grave). (Courtesy Ivan Meštrović Museums and the Ivan Meštrović family.)

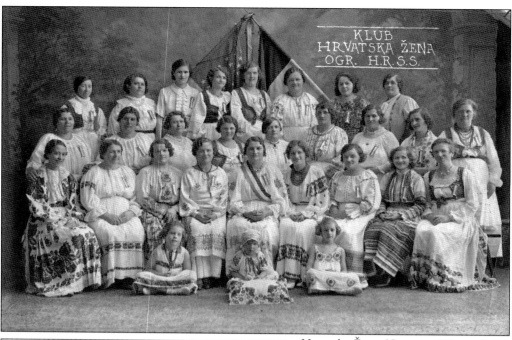

Hrvatska Žena (Croatian Woman) was founded in 1921 in Zagreb with a mission based in promoting goodwill and Christian charity. On January 27, 1929, the first branch in the United States was formed in Chicago. Agata Durak and her daughter Vilma Strunjak, with the help of Dominican priest Fr. Inocent Bojanić, founded Branch No. 1. Pictured are members of the group in 1939, dressed in national costumes representing various regions of Croatia. (Courtesy Eleanor Bozich-Grzetich.)

The State of Illinois recognized the importance of the organization and granted them a legal charter within the year. Each woman was given a paper booklet to catalogue the mission statements and their membership dues. (Courtesy Hrvatska Žena.)

Immediately after the Chicago group formed in 1929, twenty-six other branches of Hrvatska Žena registered throughout the United States. They became key pillars of their communities, supporting churches, schools, charities, and cultural programs as well as the U.S. military during World War II. To this day, they host international conferences and global charity fund-raisers. (Courtesy Hrvatska Žena.)

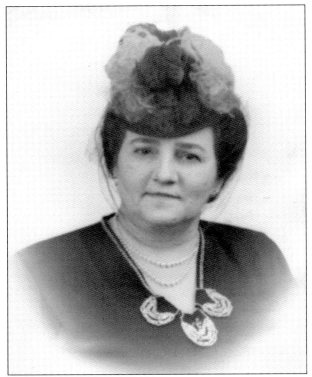

Klara Škvorc (pictured) was the first president of Hrvatska Žena Chicago. Its goal was to assist in social and humanitarian needs and also to display Croatian culture to the American people. The group immediately activated, creating exhibits throughout the Chicagoland area and participating in the World's Fair and other venues to showcase this mission. (Courtesy Hrvatska Žena.)

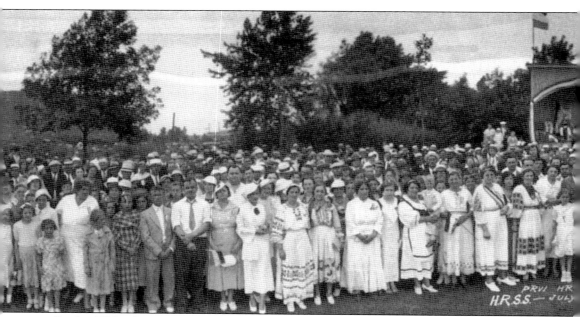

By the 1930s, there were over 60 Croatian organizations in the Chicagoland area. The fraternal organizations had numerous lodges, the churches each boasted several religious groups, Sokol clubs had several branches, and there were over five singing groups and several tambura ensembles. On July 7, 1939, Croatians gathered at the Prvi Hrvatski Narodni Dan (the First Croatian National

OPPOSITE PAGE: Picnics, parades, and processions have always been an important part of the socialization and assimilation process for the Croatian community. Pictured here in South Chicago on June 13, 1936, are members of the Ban Jelačić CFU Lodge No. 440 dressed up as famous Croatian religious, political, and military figures. The float's theme depicts moments in Croatian history. The grand marshal was Jure Brkljačić, and the queen was Ana Lončar. The CFU lodge was named after the famous Croatian Count Josip Jelačić. (Courtesy Vladimir Novak.)

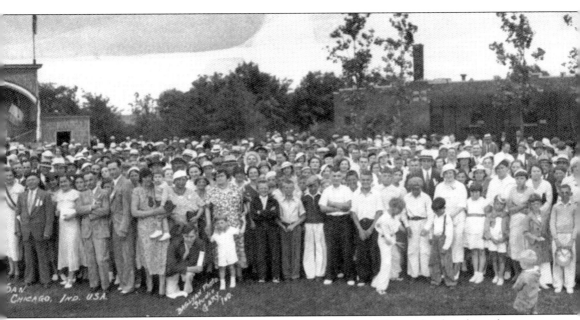

Day) in East Chicago, Indiana. Thousands of members of various Chicagoland and northern Indiana organizations were represented at the giant outdoor picnic, including women from various branches of Hrvatska Žena in the front row. (Courtesy Croatian Ethnic Institute.)

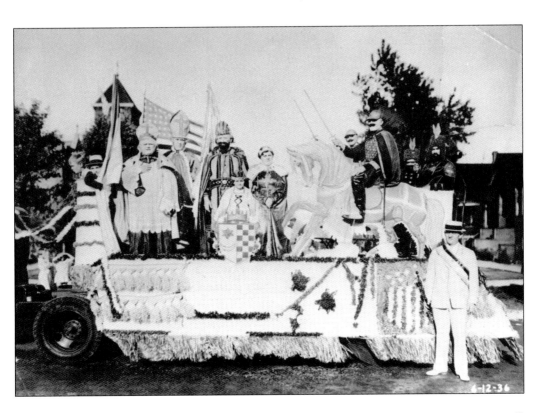

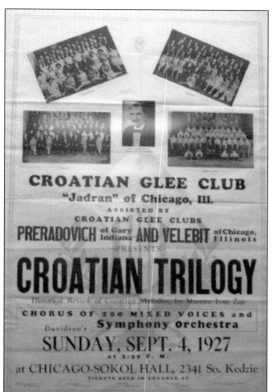

The Croatian singing choir Jadran joined other choirs to entertain audiences in the Chicagoland area. At a concert at the Chicago Sokol Hall in 1927, two additional choirs, Preradovich and Velebit, joined Jadran to perform works by Croatian composer Ivan Zajc. (Courtesy Croatian-American Radio Club.)

The Hrvatsko-Amerićki Radio Klub (Croatian American Radio Club) has been hosting Croatian-language programming since 1935. Founding member and broadcaster Ivan Majdak is pictured here. Just as the newspapers, the radio broadcasts have served a double purpose: to keep Croatian Americans in touch with developments back home and, at the same time, to introduce them to the social, economic, and political life of their new American environment. Later the club became home to the Matija Gubec folklore group and today is used by several social groups: Zagorec, Slavonija, Sinovi, and Šolta. (Courtesy Croatian Ethnic Institute.)

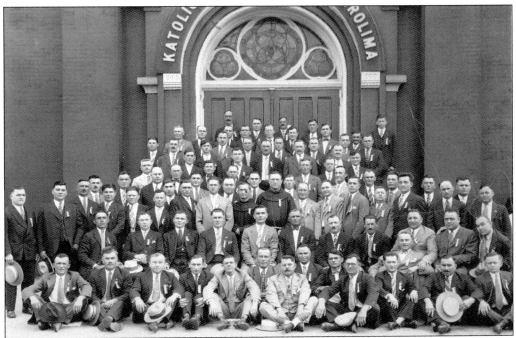

Pictured are members of Hrvatska Radiša Grana 32 (Croatian Radiša Branch 32) in 1928. Along with St. Jerome's pastor Fr. Blaž Jerković, other members of St. Jerome's parish were active, including Mr. Pešo, Mr. Željković, Mr. Nikola Šaškor, Mr. Pripušić, Mr. Grzetich, and Mr. Plišić. Formed in 1910 in the homeland, the mission of the group was to assist in the education of orphaned children in Croatia and Bosnia-Herzegovina. (Courtesy Eleanor Bozich-Grzetich.)

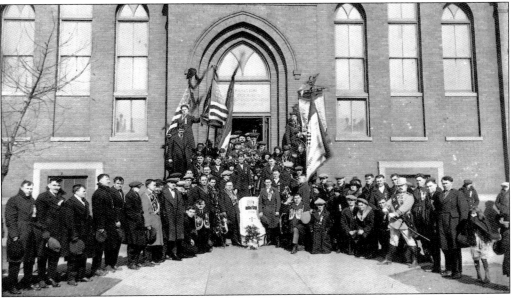

Mourners stand outside of Sacred Heart Church to pay their respects, holding banners and flags in honor of the deceased countryman. A typical Croatian funeral at the time allowed the body to be displayed in an open casket. (Courtesy Sacred Heart Church.)

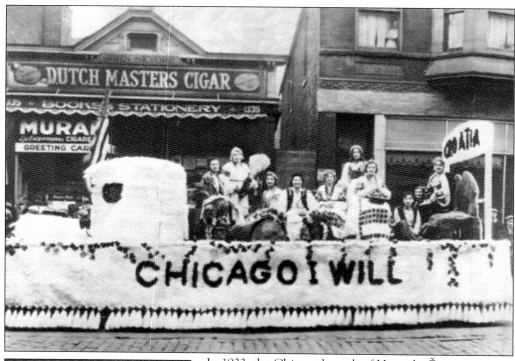

In 1933, the Chicago branch of Hrvatska Žena built a float to represent the Croatian community in festivities during the World's Fair in Chicago. Stopping in front of John Skvorc's Cigar Shop, the women sit perched on the float in traditional Croatian costumes. Sitting in front of the sign "Croatia" is Barbara Balija, symbolizing a Croatian queen on a makeshift throne. (Courtesy Vladimir Novak.)

Anxiety and concern over the independence of Croatia prompted national meetings in the early 1930s. A second Hrvatski Narodni Sabor (Croatian National Congress) was sponsored by the political organization Domobran and held in Chicago in 1935. Delegates from all over the country came and agreed on a manifesto, asking the United States to take steps and assist Croatians in their independence from Yugoslavia. The *Chicago Tribune* covered the event on December 1, stating, "Croatians Seek Freedom." (Courtesy Croatian Ethnic Institute.)

As the first wave of immigrants began to pass on, the need for Croatian-owned funeral homes became realized. Since there was no official Croatian grave site in Chicago, each church was left to liaise with the local funeral parlor to arrange cemetery plans. Josip Pavlak and his family-owned business began servicing the community in 1916. A few doors down from Holy Trinity, he and his wife were active members of the parish. Pavlak is pictured here with fellow parishioners Frances Siranović-Richo and baby Sandy. (Courtesy Sandy Richo.)

Compliments of

PAVLAK FUNERAL HOMES
Michael J. Murino - Raymond Tuminello,
Funeral Directors

THE PILSEN CHAPEL　　THE LYONS CHAPEL
1814 So. Throop St.　　4039 So. Joliet Ave.
Phone 226-1207　　　　Phone 447-1900
Chicago, Illinois　　　　Lyons, Illinois

Air Conditioned Parlors
SERVING CHICAGO AND SUBURBS SINCE 1916

SAVE WITH SAFETY
THE NATIONAL REPUBLIC BANK of Chicago
1817 South Loomis Street
(Founded 1897)
MEMBER OF THE F D I C

ANNUAL MEMBERSHIP BOOK FOR PARISHIONERS OF HOLY TRINITY CHURCH
1850 South Throop Street
Chicago, Illinois 60608

UPLATNA KNJIZICA ZA CLANOVE HRVATSKE KATOLICKE CRKVE PRESVETOG TROJSTVA
1850 South Throop Street
Chicago, Illinois 60608

Churches issued membership booklets to its parishioners. The priests would manually enter the member's information and mark the contribution made towards the annual membership. By the early 1960s, annual dues amounted to about $10 per family. Later these booklets were sponsored by neighborhood businesses to offset the printing costs. (Courtesy Holy Trinity Church.)

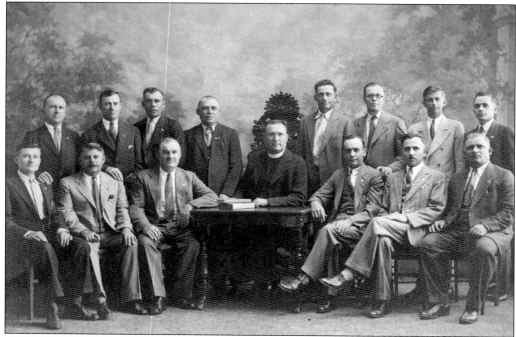

As parishes grew, so did the need to help the clergy build and expand essential services to parishioners. Church councils were established to help the priests and nuns with administrative, social, and spiritual event planning. Seated with Fr. Blaž Jerković are members of St. Jerome's Church council in the 1930s. (Courtesy Eleanor Bozich-Grzetich.)

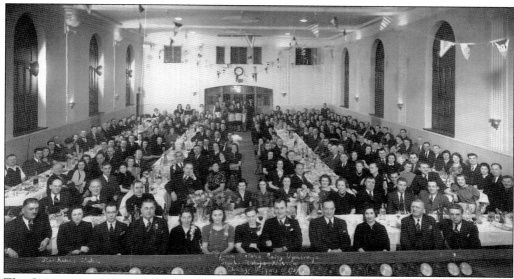

The Croatian community grew quickly, as did the guest list for special occasions. What used to be small gatherings for official events ballooned into a big social extravaganza. Slavko and Marija Klarich celebrate their wedding dinner with over 250 guests in 1939. Klarich was a member of St. Jerome's parish and successful in the construction business. (Courtesy Giggie Becich-Cortese.)

Three

PATRIOTISM AND THE SECOND CROATIAN CAPITAL

With an organized network of social, political, and religious structures in place, the first and second generations of Croatian Americans were able to comfortably assimilate and contribute to their surroundings. A significant number enlisted in the U.S. military from the collective parishes, especially during World Wars I and II. Others turned to public service. Michael Bilandić served as 11th Ward alderman and later became the first Croatian to serve as mayor of Chicago from 1977 to 1979. Eddie Vrdolyak and his brother Victor served as aldermen for the 10th Ward, while others served Cook County and the surrounding municipal areas.

Outside the Midwest, Chicago had gained the reputation as a community with a cohesive Croatian support system. As a result, many chose to come here in search of better opportunities after the end of World War II and the dissolution of the Independent State of Croatia. Their homeland had transformed into a Communist Yugoslavia, which translated into political and religious persecution for many. By the late 1940s, the imprisonment of clergy and political dissidents underscored the loss of freedoms and fueled the gradual exodus to the West. It is estimated that at least 20,000 Croatians came to the Chicagoland area after 1945.

Socially the community swelled. Neighborhoods gained acclaim for their annual religious Velika Gospa celebrations at St. Jerome's in Bridgeport and Holy Trinity in Pilsen. The South Side became known for its fun dances at the Croatian Hall. The Došen Grove inspired families to go outdoors for their Sunday picnics. These outlets opened the door for a larger network of second-generation Croatians to meet, giving parents further hope for potential dating encounters. Many matchmakers succeeded.

The Croatian Franciscan Press and other printing houses helped Chicago become an influential communications hub by promoting and preserving ethnic identity through various print media. Croatian-language radio stations helped disseminate news and unite those patriotic to a future independent homeland. Croatian language schools and folklore groups reinvigorated the need for ethnic identity and expression. As a result, the community regenerated with grass-roots activity towards the realization of a future independent Croatia and soon after was dubbed the "second Croatian capital."

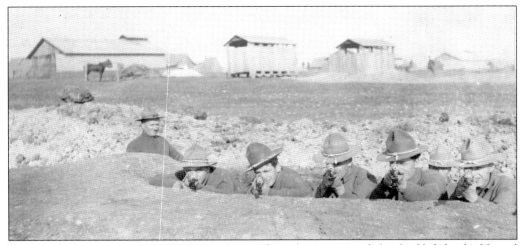

Thomas Blažina was born in 1893 in the region of Gorski Kotar. His father had left for the United States in 1898 and died shortly after while working in a coal mine. His mother, Mary, moved to Chicago, remarried, and soon after sent for Tom and his siblings to join her. Blažina (pictured second from right) joined the Illinois National Guard, served with the Fighting Irish Illinois 7th Infantry, and was deployed to the Mexican border in 1916 to help with the hunt for Pancho Villa. (Courtesy Joe Blažina family.)

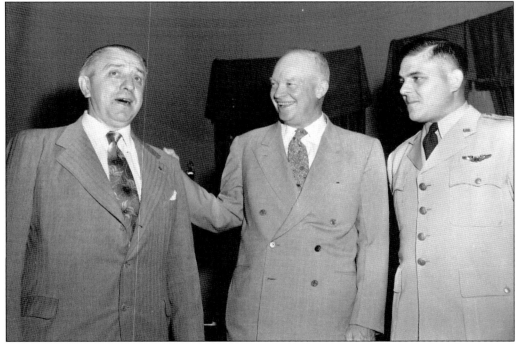

While in Mexico, Blažina was assigned to Lt. Dwight D. Eisenhower, where together they formed a memorable bond. Tom publicly reunited with his military friend during Eisenhower's election primary stop in Chicago in 1952. Tom and his wife, Frances, were later invited to Palm Springs to attend a farewell reception given in President Eisenhower's honor at Smoke Tree Ranch. Tom and his son Tom Jr. are pictured here with the president. (Courtesy Joe Blažina family.)

Frank Širanović attended Holy Trinity Elementary School and St. Procopius High School. He was active in the community and belonged to the Holy Trinity church choir and lodge No. 25 of the Croatian Catholic Union. He worked at Pere Marquette Railroad Company until he left for the war. He was inducted into the U.S. Army in July of 1942. He died at 34 while serving in North Africa. (Courtesy Sandy Richo.)

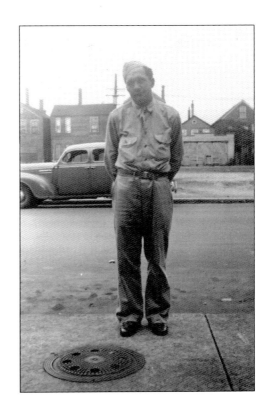

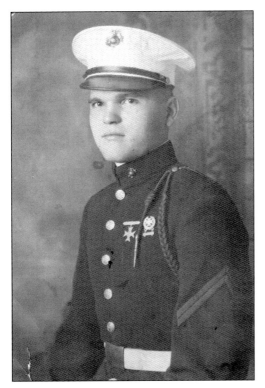

Steve Matalin arrived from Zagreb when he was about 15 years old. While en route to the United States, he met a young Dalmatian girl Helen Tomašević. He later married Helen at Sacred Heart Church and settled down on the South Side. Matalin enlisted in the U.S. Marines at the age of 17 and served in China in the 1920s. He worked at Naylor Pipe Company and was one of few men fortunate enough to work during the Depression. (Courtesy Matalin family.)

Enlisted in the U.S. Armed Forces during World War II from Sacred Heart Church were 707 members; 21 never returned. Pictured here are five sons from the Perkovich family who served in the U.S. Army and U.S. Navy from 1942 to 1946, earning ribbons and medals for their achievements. From left to right are (first row) Robert and Daniel; (second row) Louis, Steve, and Matthew. (Courtesy Mandy Perkovich-Došen.)

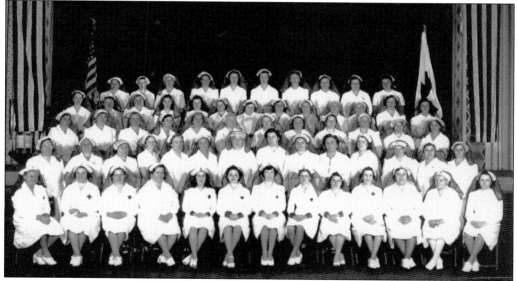

During World War II, more than 60 women came together to establish the Sacred Heart American-Croatian Red Cross Unit. In their spare time, they made bandages and supplies for the U.S. military abroad. Many were wives and mothers of the parish's enlisted service personnel. Some of those pictured include Mrs. Nikšić, Mrs. Tergovac, Mrs. Srdić-Jurko, Mrs. Božich, Mrs. Bandera, Mrs. Bacich, Mrs. Pleša, Mrs. Peterlich, Mrs. Jamić, Mrs. Tomich, and Mrs. Kopilash. (Courtesy Stefi Došen-Magnavite.)

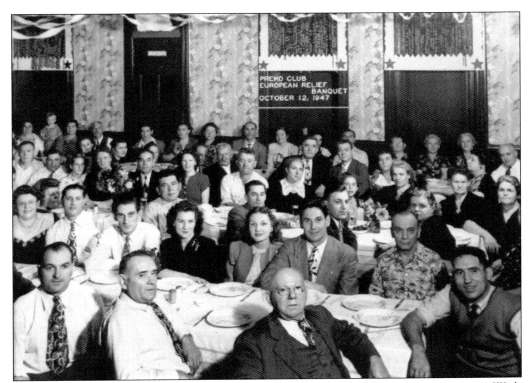

The rebuilding after World War II was of great interest to the Croatian community. With the enactment of the Marshall Plan, also called the European Recovery Program, the United States hoped to help Western European countries in the postwar economic crisis and to give these nations a chance to stand up against the spread of communism. Members of St. Jerome's Club Preko, pictured above, organized a European Relief Banquet on October 12, 1947. The proceeds went towards relief supplies to the affected nations. Special collections during Mass were initiated by churches and collected in envelopes like the one pictured below. (Both courtesy St. Jerome's Church.)

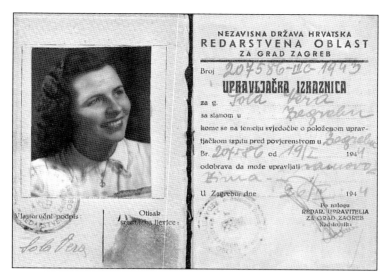

An Independent State of Croatia (Nezavisna Država Hrvatska or NDH) was formed in Europe from 1941 to 1945. During this brief period of sovereignty, a Croatian central bank formed; a new currency, the kuna, was issued; and efforts were made to rename official venues. It also meant the official use of the Croatian language, as shown on the driver's license here. (Author's collection.)

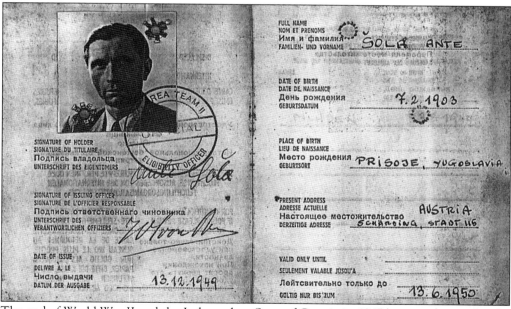

The end of World War II and the Independent State of Croatia in 1945 became the catalyst for the next wave of Croatian immigrants. The loss of governance and the formation of a Communist Yugoslavia in 1946 led to death and imprisonment of outspoken clergy, journalists, and political dissidents. Many escaped by foot seeking asylum in neighboring countries, crossing rivers and the Italian Alps with little children and baggage in hand. It is estimated that at least 20,000 Croatians came to the Chicagoland area after 1945. (Author's collection.)

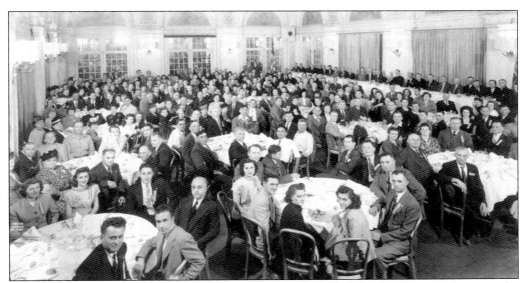

Attracted by Chicago's reputation as a patriotic and cultural hub for the Croatian diaspora, the community was reinvigorated with new political refugees and intellectuals fleeing Marshal Tito's rule in Communist Yugoslavia. Solidarity in numbers proved to be a successful way to promote political, humanitarian, and charitable awareness. The Croats organized national conventions, like the one above, to unite efforts and goals. The United American Croatians met in a Chicago hotel for the Second Croatian Congress on February 29, 1949. (Courtesy Croatian Ethnic Institute.)

Political groups were active participants and contributors to events in the homeland. The Hrvatska Seljačka Stranka (HSS), the Croatian Peasant Party, dates back to 1904 as a centrist party in Croatia. Here members of Chicago's HSS have organized a dinner at St. Jerome's to welcome the HSS secretary general from Croatia, Dr. Juraj Krnjević, in 1947. Today the HSS considers itself among other left-wing European political parties. (Courtesy Giggie Becich-Cortese.)

These youngsters of Sacred Heart Church celebrate their First Holy Communion in May 1939. An envelope donation system was begun to help with improvements and other church property maintenance. By 1939, the church was able to purchase the Croatian Hall, which continued to flourish as the neighborhood social center. Identified in the first row are Margie Pleša-Došen (first from left), Anthony Sudar (fifth from left), and Nick Rukavina (fourth from right). (Courtesy Stefi Došen-Magnavite.)

Fr. Špiro Andrijanić became pastor of Sacred Heart Church in 1931. Pictured here in 1941, Father Špiro is at an outing with some of his youth choir members. From left to right are (first row) Rose Brnčić-Boerner, Mary Spretnjak-Gašpar, Margaret Srdić, Ann Prša-Bertemese, and Rose Santić; (second row) Father Špiro, Irene Krčmarić, Sister Bernandine, unidentified, and Mandy Perkovich-Došen. (Courtesy Sister Tomasin Novakovich.)

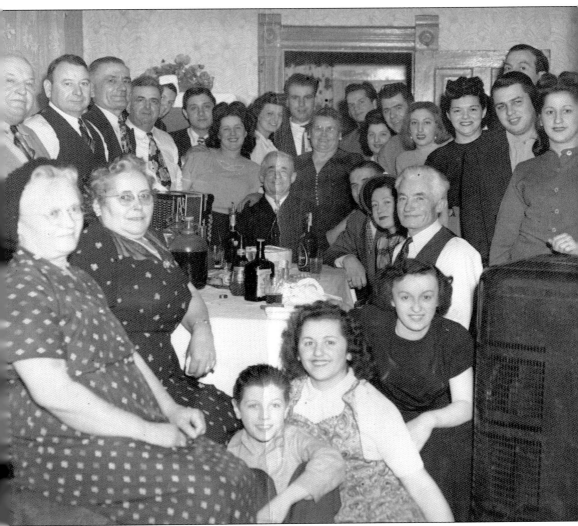

While birthdays are important dates to remember, name days are more likely to be celebrated in Croatian households. Pictured here on March 19, 1949, Jozo Becich enjoys a house full of guests to celebrate the Feast Day of St. Joseph, his namesake. Complete with an accordion player and plenty of bottles of homemade wine and "rakija" (brandy) on the table, friends and family join the festivities in his home at 339 West Thirtieth Place. To this day, three generations of Becich descendents have lived on West Thirtieth Place in Bridgeport. All have been active members of St. Jerome's Church over the years. Jozo was known for his lamb-roasting duties at the annual Velika Gospa celebrations. His daughter Giggie had long organized the annual Velika Gospa processions, and today Jozo's grandson Louis Scalise serves as chairman. Pictured here are (from left to right, sitting in front) Ivka Bozich, Andrica Aljinovich, Joey Bozich, Marian Becich-Segvich, and Eleanor Granich; (sitting, back center) Jozo Becich; (standing, left of Jozo) Tonka Becich-Scalise; (standing, left of Tonka) Tonka's husband, Frank Scalise; (standing, right of Jozo) Jakica Becich; (standing far right, right to left) Giggie Becich, Chuckie Cortese, and Fran Tadin. (Courtesy Louis Scalise.)

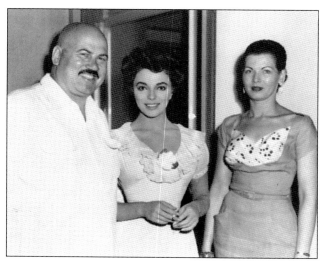

Born in Chicago in 1911, Joseph S. Marušić was raised in Bridgeport and attended St. Jerome's. A professional wrestler, he earned the nickname "Tiger Joe." In 1937, he was the world heavyweight champion and by the 1950s had participated in over 3,000 matches. Tiger Joe moved to Hollywood and was cast as an original model for the first Mr. Clean advertisements. He changed his name to Joe Marsh and has appeared in several films and television shows. Joe poses with Joan Collins (center) here. (Courtesy Vladimir Novak.)

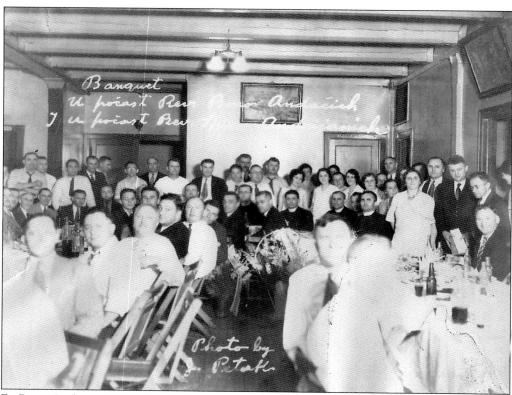

Fr. Bono Andačić served Sacred Heart Parish in the 1930s. A banquet was made in his honor at Bob and Mary Soldo's restaurant Bob's Place on Ewing Avenue on the South Side. Mary, standing on the right next to a priest, ran the kitchen and cooked with her husband. (Courtesy Mirko Soldo family.)

Pavao Kelečić-Kufrin was born near Samobor in 1887; he came to Chicago in 1906. Having studied with several artists in Zagreb, he was quickly able to find work at a company specializing in the manufacturing of bronze panels. By 1910, he opened his own art school on Division and La Salle Streets. Kufrin was known for his famous busts of prominent figures and won a gold medal at the 1934 World's Fair for his bust of Clarence Darrow. Pictured at right in the late 1930s, he works on the bust of former Chicago mayor Anton J. Cermak. Kufrin's works include the Assyrian Room at the Field Museum in Chicago. Kufrin is pictured below working on an architectural panel in the late 1950s. His famous panels include the bas-relief on the facade of the Portland Cement Association Research Center in Skokie, Illinois. (Both courtesy Immigration History Research Center, University of Minnesota.)

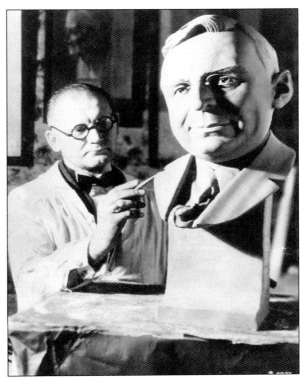

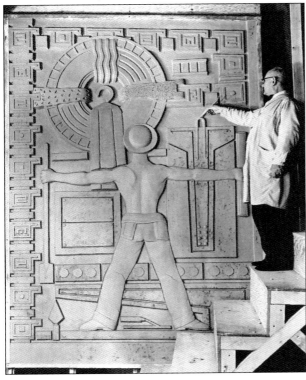

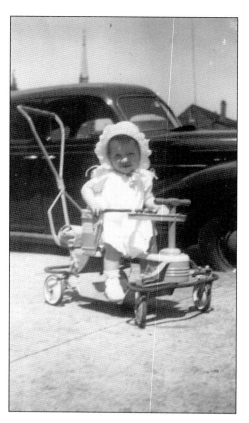

Much like other ethnic neighborhoods at the time, the streets around Holy Trinity Church were always full of kids and families. It was a place where "everybody knows your name" and where almost every other house had a Croatian mother watching like a hawk out the window, ready to step in and patrol the activity outside. Little Sandy sits in her 1940s baby stroller near Eighteenth and Throop Streets. (Courtesy Sandy Richo.)

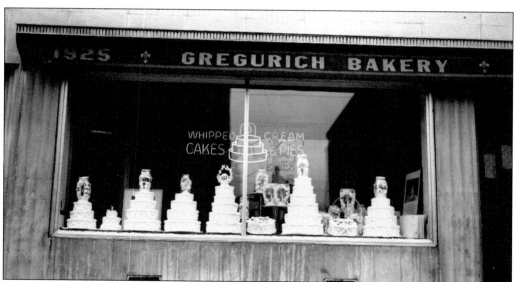

Many Croatian-owned businesses flourished in the Pilsen area. The Gregurich Bakery on 1925 South Racine Avenue was well known to local Croatian families, especially during the holidays and for special occasions. The bakery was a few doors down from the Hrvatski Narodni i Sokolski Dom (Home of the Croatian Hall and Falcon Club). (Courtesy Antoinette Ptiček-DeWitt.)

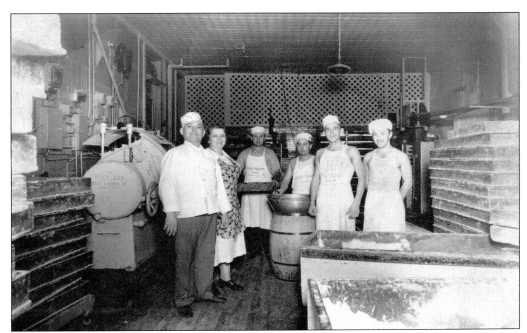

John Ptiček left Zagorje, in northern Croatia, at the age of 12. He arrived in Chicago to join his two sisters in 1925. He quickly went to work and saved enough money to buy his first business. Mr. and Mrs. Gregurich (on the left) sold their bakery to John (second from right) in 1943. Ptiček kept the Gregurich name until they moved to the present-day Ptiček Bakery on Fifty-fifth Street and Narragansett Avenue west of today's Midway Airport. (Courtesy Antoinette Ptiček-DeWitt.)

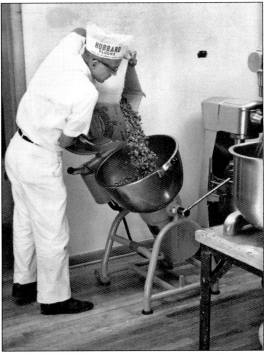

Ptiček married Antoinette, a Bohemian-Croatian American. They had two kids, also named John and Antoinette, and remained active members of Holy Trinity Church. Pictured here in 1959, John woke up every morning 1:00 a.m. to make Orahnjače (a Croatian walnut pastry) and other Croatian and Bohemian pastries. Ptiček worked up until the day he died at the age of 89. His wife still works at the Ptiček Bakery and answers the phone, while his children and grandchildren proudly continue to serve customers. (Courtesy Antoinette Ptiček-DeWitt.)

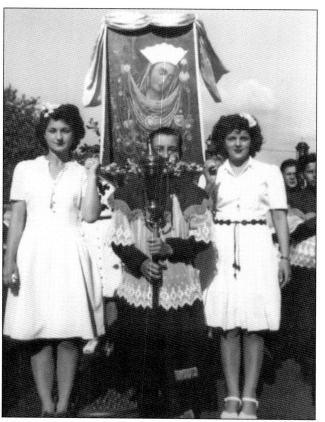

St. Jerome's Church has enjoyed continued success for its annual summer religious celebration of Velika Gospa. Since 1913, neighboring Italians, Poles, and other Catholics have flocked to Bridgeport to join the Holy Procession and social gathering. Princeton Avenue and adjacent streets are customarily blocked off to allow for bands, marchers, and groups to circle the neighborhood. Pictured at left are young women leading the Holy Procession, dressed in white, carrying the image of Our Lady. After the Holy Mass, the street festival begins as hungry guests, like little Katica Ostojić, seen below, feast on roasted lamb and pig and other Croatian specialties. Parishioners volunteer their time and expertise to prep, cook, and organize the festival. Live music and folk dancing have entertained crowds through midnight. (At left, courtesy St. Jerome's Church; below, Croatian Ethnic Institute.)

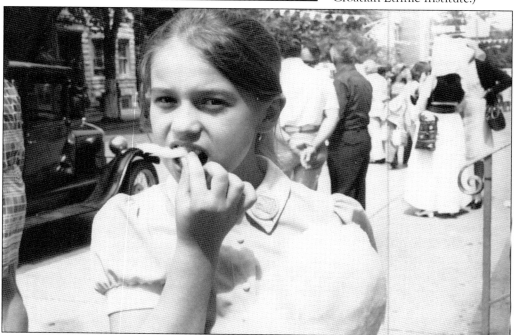

The Honorable Nicholas J. Matković was a lifelong resident of Bridgeport and a member of St. Jerome's Church and Club Sinj. He had a distinguished legal career and proudly served in the U.S. Army as a captain with the counter-intelligence unit during World War II. Matković was an attorney for the Illinois Secretary of State, a municipal court referee, an assistant trial judge, and served as a Cook County Circuit Court judge from 1962 to 1980. In 1963, he presided over a trial involving *Playboy* magazine founder Hugh Hefner. He continued to support his Croatian community and frequently advertised his legal services to help the Croatian church in its fund-raising efforts. Matković, along with other influential Chicago dignitaries, participated in the many celebrations of Velika Gospa. (Both courtesy St. Jerome's Church.)

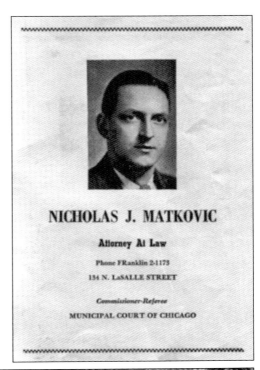

SACRED HEART CHURCH BLDG. FUND

DANCE

Saturday, January 26, 1957

CROATIAN HALL, 9618 Commercial Ave.

Admission after 9:30 P. M. only

Donation $1.00

Fund-raising for churches, clubs, and schools was becoming a normal part of the social calendar, and for many it became a lifelong benefit. For only $1, parishioners combined drinks and dancing to contribute to a good cause. It was here at these church socials that many couples met and later married. (Courtesy Croatian Ethnic Institute.)

As a newcomer, part of the American experience meant the purchase of a new car. And if that was not the case, then posing next to an American car was the second-best option. Milan Braovac and Jozo Dugandžić pose in front of Milan's car on the South Side. Photographs such as these were sent to relatives back home as a testament to their American status and success. (Courtesy Vida Vučić.)

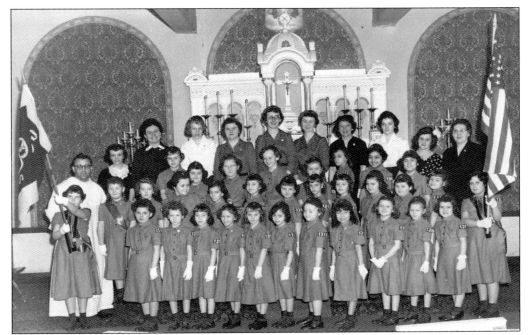

Fr. Steve Budrović blesses the first Holy Trinity Croatian Brownie Troop No. 1311 and their official scout banner during a morning Mass on February 5, 1956. Included here are some of the members of the troop: Anna Dekanić, Mildred Slaviček, Linda Sirovica, Sandy Richo, and Patricia Mikulić. Leaders of the troop were Patricia Biskupić, Harry Bonelli, and Mary Čakanić. (Courtesy Sandy Richo.)

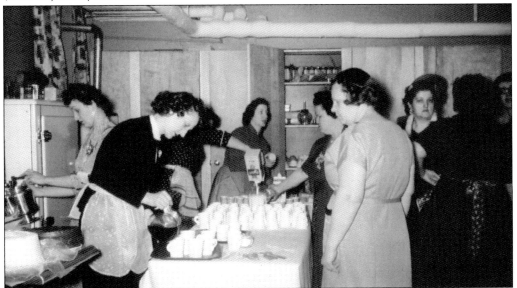

Fr. Budrović and Fr. Inocent Bojanić allocated church funds to build new rooms in the church basement for the Holy Trinity Brownie and Girl Scout troops, complete with a locker for each group and new kitchen facilities. Croatian mothers join Frances Širanović-Richo (second from left) in preparing snacks for a troop event in the church basement. (Courtesy Sandy Richo.)

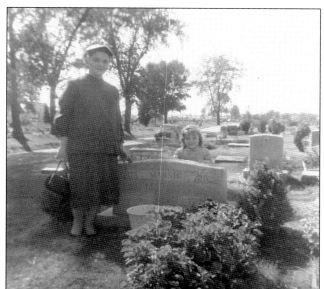

The annual Roman Catholic holiday Svi Sveti, or Sisvete (All Saint's Day), brings worshippers to visit the graves of their family members and friends on November 1. Special Masses are given and graves decorated with candles and wreaths. Mary Ann Maršić and three-year-old Susan Maršić-Gordon stand before the graves of Ivan and Katarina Maršić in 1958 at St. Mary's in Evergreen Park Cemetery. The Maršić family emigrated from Sošice, Croatia, in the early 1900s. (Courtesy Margaret Maršić-Gariota.)

Mother's Day programs are an annual tradition to celebrate Croatian heritage. Since the 1950s, children from the various Chicagoland church and folklore groups have danced, sung, and performed for their mothers. Children of Holy Trinity Church entertain a Mother's Day audience gathered at the Bohemian-American Hall on Eighteenth Street. The tradition continues today at Croatian parishes. (Courtesy Antoinette Ptiček-DeWitt.)

The major Croatian churches established schools on the parish grounds. The first classrooms built at Holy Trinity could accommodate about 350 children. The School Sisters of St. Francis arrived from Lemont, Illinois, and remained as the teaching faculty. By the mid-1900s, the neighborhoods were changing and an influx of other nationalities had blended in. The eighth-grade classroom in 1961 had a mix of Croatian, Hispanic, and other European surnames. (Courtesy Sandy Richo.)

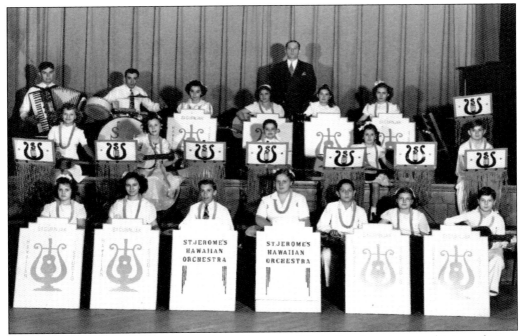

The 1940s and 1950s were known as the golden age of Catholic education, combining religious teachings with extracurricular activities. Pictured here is St. Jerome's Hawaiian Orchestra, including an accordion player. In 1932, St. Jerome's had its first eighth-grade graduation with 13 graduates. Over the years, the school continued to grow, with its highest enrollment of 534 children from 1953–1954. Since it first opened its doors in 1922, over 2,200 children have graduated from St. Jerome's. (Courtesy St. Jerome's Church.)

Croatian Franciscans have worked in North America since the early 1900s along with Slovenian and Slovak friars. In 1926, the Holy See established a Croatian commissariat under the name of the Holy Family, which was then placed under the jurisdiction of the Mostar Province in 1931. At the time, only the Herzegovinian Province was able to send large numbers of Franciscans to the United States to fulfill the pastoral needs of the growing number of Croatian immigrants. In order to develop and intensify their work, they needed a central monastery and a strong publishing presence for North America. They purchased a building in Hyde Park, which had belonged to the University of Chicago but had been the residence of businessman and philanthropist Martin Ryerson. Soon after, they purchased an adjacent property where the chapel of St. Anthony and eventually the Croatian Ethnic Institute was added. For decades, celebrations and picnics have been held on the grounds, including the annual feast of St. Anthony on June 13. (Both courtesy Croatian Ethnic Institute.)

The Croatian Franciscan Press began operating in 1947. Since then, the friars have published a variety of content that has helped sustain and preserve Croatian identity. Over the years, immigrants have stayed informed with publications like the Croatian weekly *Danica*, the monthly *Croatian Catholic Messenger*, and the yearly *Croatian Almanac*. Organizations have used the printery to produce booklets and pamphlets in over nine languages, while individuals have had the opportunity to publish books, poems, and even order personalized wedding invitations. (Courtesy Croatian Ethnic Institute.)

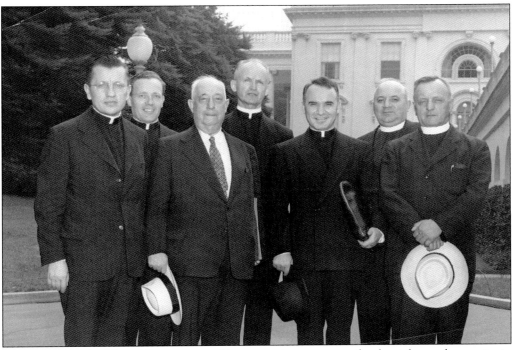

Many clergy in the United States engaged in promoting awareness for the rights and sovereignty of the Croatian people. The group pictured here presented a memorandum to Pres. Dwight D. Eisenhower on June 15, 1954. Fr. Silvije Grubišić (third from right) was a well-known pastor, editor, and translator of the Holy Bible. While in Chicago, he was the first editor of the monthly publication *Hrvatski Katolički Glasnik* (Croatian Catholic Messenger), which began circulation in 1942. (Courtesy Croatian Ethnic Institute.)

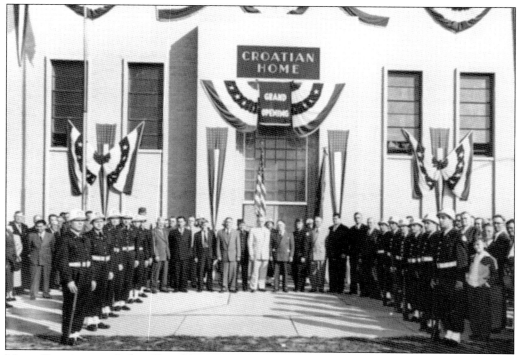

Many Croatians settled in East Chicago, Indiana, to work near the steel mills. The Croatian Home was built in 1960 on Main Street. Along with fellow founding members, John Vukovič and John Ceperich stand next to the white-suited Mayor Frank Migas. The hall was active for almost 20 years, but when the steel mill industry declined, so did interest. The Hall closed and the building was sold in 1981. (Courtesy Vladimir Novak.)

The South Side Croatian Hall on Commercial Avenue was used for weddings, banquets, concerts, and other special occasions. Many Croatian couples met there and eventually married. Over the years, it has been owned by Sacred Heart Church and the Eddie Vrdolyak family. The building, with its inscription, still stands. (Courtesy Bane Banović.)

George Mikan was born in Joliet to George and Minnie, who arrived in the early 1900s from Vivodina, near Karlovac. He finished high school in Joliet, where he polished his basketball skills. He was accepted to DePaul University and led them to the 1945 National Invitation Tournament championship. From there, his career skyrocketed. Nicknamed "Mr. Basketball," Mikan later retired to spend more time with his family and work on his law career, but he remained active in many areas of professional basketball. (Courtesy Jim Mikan family.)

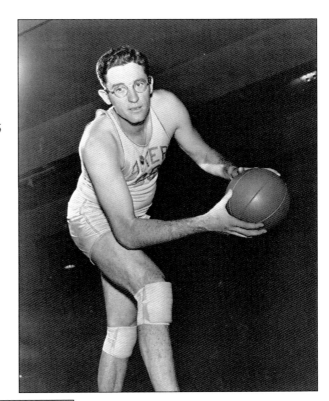

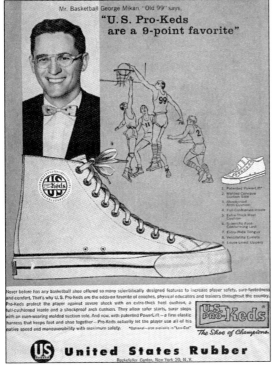

During his professional years, Mikan led his teams to seven championships in nine years, including five NBA titles, and introduced the "shot clock" to basketball. He played with the Chicago American Gears from 1946–1947 and then the Minnesota Lakers from 1947–1956. By 1950, the *Associated Press* named him the greatest player of the first half of the century. Mikan was inducted in the Basketball Hall of Fame in 1959. In 1996, he was honored as one of the NBA's Top 50 Greatest Players. (Courtesy Jim Mikan family.)

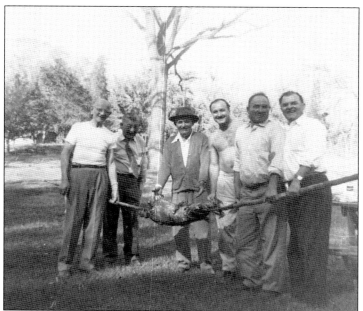

The Dan Ryan Woods on Eighty-seventh Street and Western Avenue was a popular spot for outdoor picnics. Men would come early in the morning to set up the wood chips to roast pigs and lambs and enjoy a late afternoon lunch. In the good old days, the roasts were hand-turned on branches. Today electric spits have eased the back-bending process. Pictured here are Peter Wolder (far left), Tony Trinka (fourth from right), and other St. Jerome parishioners. (Courtesy John Aranza.)

Stjepan Vrančić arrived in the mid-1920s. He soon met and married Ivka Strukelj. In 1928, he purchased the Calumet City–based printery Hrvatska and transferred it to Pilsen. He renamed it the Croatian Publishing Company. An active member of Holy Trinity Church, he helped found many early organizations and later helped finance the North Side Croatian Cultural Center. Here he stands (right) with Slavko Fumić inside his Vrančić Tavern on Allport Street. (Courtesy Marija Fumić.)

As the community grew, so did the guest list for special occasions. Weddings were held in social halls with full orchestras playing. Pictured here are bride and groom Bill Kure and Joan Kauzlarić-Kure with Dr. Jakopić and his wife, Ruby, on the right. Dr. Jakopić was a well-known physician in the community. (Courtesy Sandy Richo.)

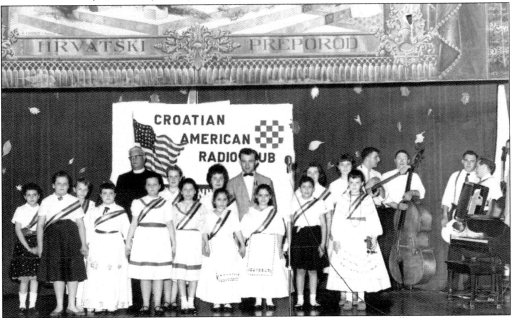

Holy Trinity Church organized a folklore dance group in 1960. Led by Mato Žakić and Fr. Inocent Bojanić, they performed on WGN and the *Ron Terry Polka Party Show* in the early 1960s. To ease transport costs, Father Bojanić arranged a CTA bus to take the group to their performance venues. The group is pictured here in 1961 performing for the Croatian American Radio Club banquet at the Croatian Hall in South Chicago. (Courtesy Steve Žakić.)

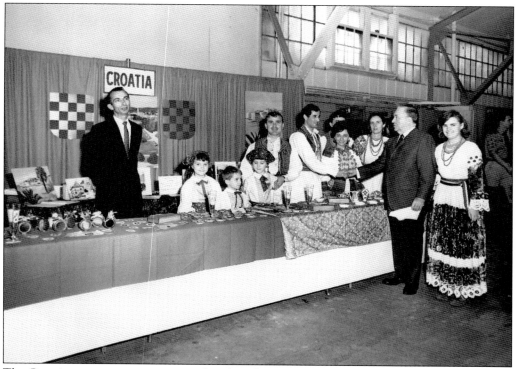

The Croatian community participated in their first International Folk Fair at Navy Pier in 1960. For the next decade, groups participated annually in decorating the booth with various Croatian artifacts, books, and (of course) food samples. Dressed in regional folk costumes, Marija Pesha (far right) and other volunteers greet Mayor Richard J. Daley as he stops to admire the display. (Courtesy Croatian Ethnic Institute.)

Members of the clergy, both priests and nuns, have become an extended part of Croatian families. In addition to official duties, they are also invited to homes for special occasions and holidays. Fr. Paul Maslać (left) and the late Fr. Marko Kozina (right) have served as pastors for the Chicago community since the 1960s. Together they have held many roles at the Croatian Franciscan Custody of the Holy Family. The late Father Marko was well known for his storytelling and wit. (Courtesy St. Jerome's Church.)

Numerous political organizations have had active chapters in Chicago: Ujedinjeni Američki-Hrvati (United American Croatians), Hrvatska Seljačka Stranka (Croatian Peasant Party), Otpor (Croatian National Resistance), the Hrvatski Domobran (Croatian Guardians of Liberty), and others. These groups frequently held dinner banquets in hotels and cultural halls with guest speakers, clergy, folklore groups, and bands taking part in the official programs. For decades, formal events revolved around commemorating April 10, the date of the Independent State of Croatia's (NDH) declaration of independence in 1941. (Courtesy Croatian Ethnic Institute.)

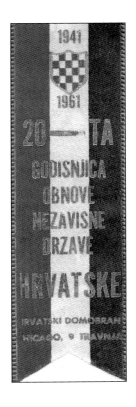

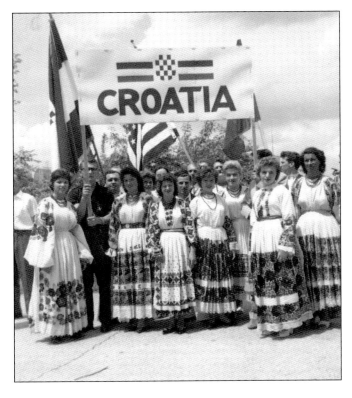

The Hrvatska Plesna Grupa (Croatian Dance Group) was founded in 1959 by Sandra Šola and later became the Hrvatska Foklorna Grupa (Croatian Folklore Group). The group performed at the official 1962 opening ceremony of Chicago's O'Hare Airport. Pictured here is a group participating in the annual Chicago Spring Festival in Grant Park in 1961. In front from left to right are Marion Aguiler, Darko, Josip Murr, Zrinka Šimatić-Dzinich, Astrica Šimatić, Ivica Somers, Maria Pesha, Nada Gustafson, Ivanka Malez, Dave Mesić, and Ivanka Šimatić. (Courtesy Croatian Ethnic Institute.)

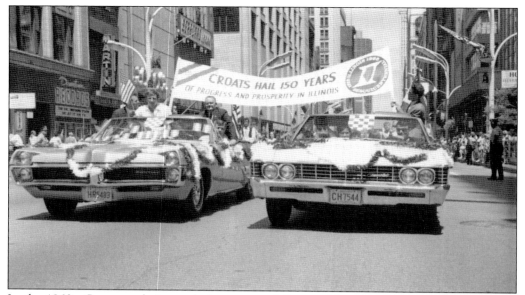

In the 1960s, Congress designated observance of Captive Nations Week to stress that many nations had been forced to live under Communist regimes after World War II. Annual parades and marches down State Street included the participation of U.S. Navy marching bands and processions of various nationalities representing their countries. Governors and mayors participated in the official parade-viewing. Croatian dance groups, both young and old, dressed in native costumes and walked the route, waving to spectators. Other events, such as speeches and film presentations, were held at libraries and other public venues to raise awareness. (Both courtesy Croatian Ethnic Institute.)

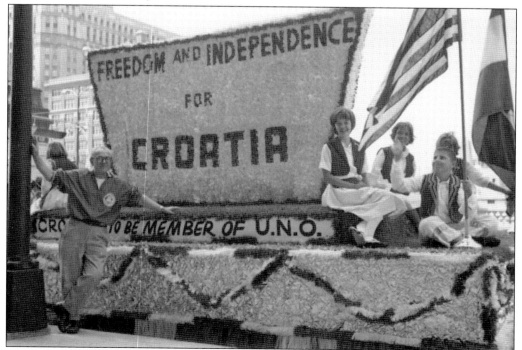

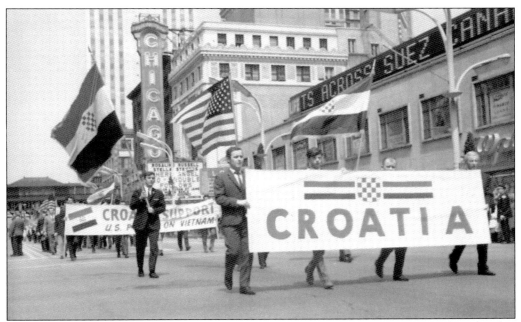

For almost 10 years, Croatian organizations came together to participate and march with other countries whose lands were behind the "Iron Curtain." Politicians, priests, and laymen joined more than 8,000 people as they marched down Chicago's busy shopping district on State Street. Floats were built, and others walked carrying flags and banners in support of both the United States and hopes for Croatian independence from Yugoslavia. (Courtesy Jakov Šola.)

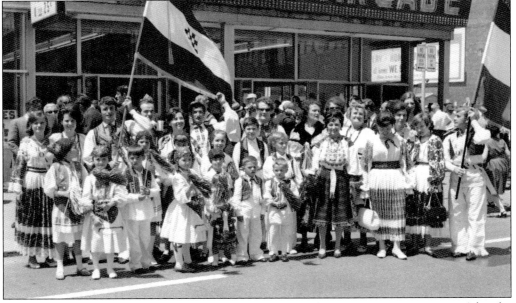

Both young and old dressed up in native costumes reflecting the various Croatian regions. After the parade, participating groups gathered at the Sherman House Hotel for an official dinner. Over the years, anywhere from 14 to 30 national groups were present as U.S. government officials, members of the U.S. military, and special delegations addressed the seated guests. (Courtesy Jakov Šola.)

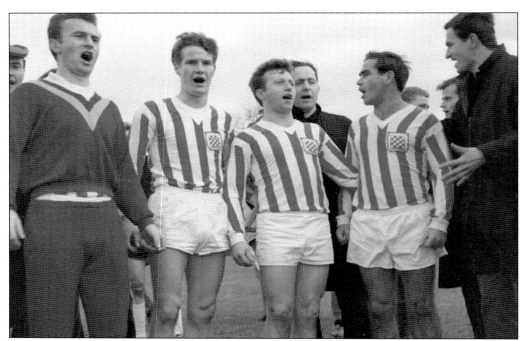

Politics and sport were one and the same in an era when national identity was displayed on the field. Supporters flocked the benches carrying flags and singing patriotic songs to support the early teams. Croatia—later named Adria (Jadran), then RWB Adria (Crven-Bijeli-Plavi-Jadran)—formed on the South Side at the home of Anna Paun in 1959. Croatan (Hrvat), formed in 1963. Above, from left to right, Hrvat members Joža Tadijanović, Ivan Dugandžić, Joe Vadas, and Joe Pestić enjoy a victory on the field with fans. Both teams were sponsored by local Croatian business owners and opened clubhouses on South Commercial Avenue. Many of the players transferred between the two teams over the years. Pictured below is the 1964 Jadran team. From left to right are (first row) Bruno Ogović, Davor Mesić, Tony Sivak, and Ben Williams; (second row) Slavko Renko, Željko Starčević, Vlado Bašić, Viktor Franović, Gilbert, Sergio Ogović, Joe Stibi, Željko Turkalj, and Mirko Čeh. (Above, courtesy Marijan Dugandžić; below, Slavko Renko.)

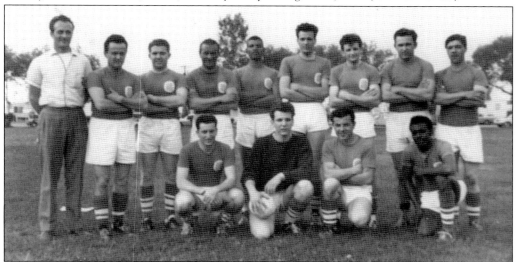

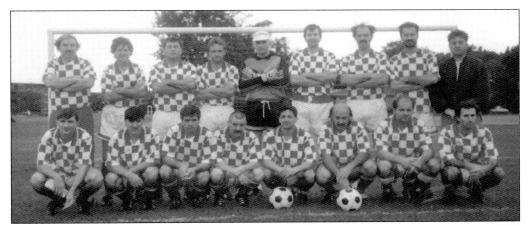

The Concordia Soccer Club was founded in 1976 by Andrija Vasilj. At the suggestion of Fr. Hyacinth Eterović, the name was chosen for its Latin meaning of "harmony" and "with one heart." The team still plays today. Pictured here is one of the earlier teams. From left to right are (first row) Nick Došen, Ivan Beš, Anto Budimir, Nediljko Vrteno Jukić, Ivan Marijanović, Bruno Bakija, Ante Mihaljević, and Franjo Horel; (second row) Pero Padjen, Jura Brkljačić, Marijan Mihalić, Jozo Malkoč, Giro Jukić, Andjelko Čubelić, Mate Milković, Slavko Doko, and Stjepan Vujica. (Courtesy Concordia Soccer Club.)

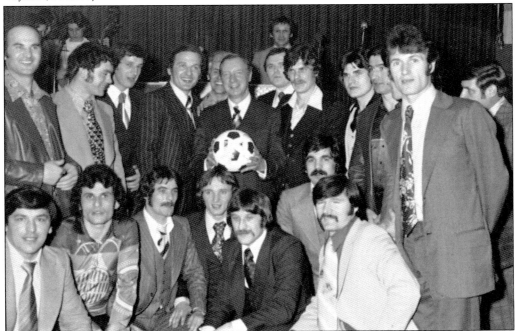

The Hrvatski Nogometni Savez (Croatian Soccer Federation) for the United States and Canada was founded in 1964. Croatian soccer players pose with then Mayor Michael Bilandić at an awards ceremony in 1977. From left to right are (first row) Franjo Bašan, Giro Jukić, Nedo Jukić, Joe Malkoč, Karlo Šimatić, Pero Marković, and Nick Markulin; (second row) Ilija Pavljašević, Tony Vincetić, Mađar, Bane Banović, Mirko Čorić, Mayor Michael Bilandić, Zdravko Vujić, Martin "Jackie" Rukavina (in the back), Ivan Novak, Marinko Volarević, Mile Štimac, and Halid Ibrahimović. (Courtesy Hrvat Soccer Club.)

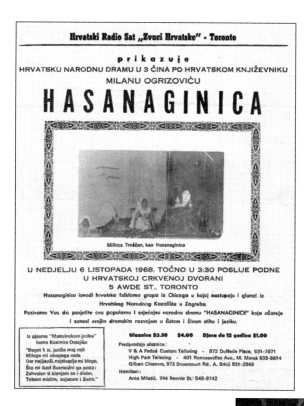

From the 1960s through the late 1980s, several plays and films were produced and performed for audiences in the United States and Canada. Members of the Hrvatska Foklorna Grupa and other artists performed under the direction of Sandra Šola. Plays and films like *Božićna Prica*, *Zlatarovo Zlato*, *Posljedna Kraljica Bosanska*, and *Ukleti Hotel* entertained diaspora while making use of local talent. (Courtesy Croatian Ethnic Institute.)

Croatia Studio formed in Chicago with the help of Sandra Šola and produced several motion pictures in the early 1970s. The first Croatia Studio film, *Hasanaginica* (Hasan Aga's Wife), premiered in 1973 at the Dank House on Western Avenue. The play was first published by Alberto Fortis in his 1774 book *Viaggio In Dalmazia* (A Voyage in Dalmatia). Pictured with fellow cast members is lead actress Olga Ladika-Dizdar (third from left). (Courtesy Croatian Ethnic Institute.)

The pastoral work of the Croatian Dominicans on the North Side began in 1972, but the momentum started with the first Mass in 1973 at St. Jerome's on Lunt Avenue and Paulina Street. The founding priests were Fr. Hyacinth Eterović, Fr. Nikola Dugandžić, and Fr. Ivo Plenković. Soon they began using St. Henry's on the corners of Ridge and Devon Avenues for special Masses. Pictured at right is the church, which was built in 1863 to initially serve the Luxembourg farming community. The grave of Robert Muno Ruckheim, the famous "Cracker Jack Boy," is buried in the church's cemetery. Working under the auspices of the Croatian Catholic Angel Guardian Mission, the Dominicans officially took over St. Henry's in 1981. Croatian Dominican nuns also moved in and added Croatian-language day care for many years. Fr. Hrvoje Blaško arrived later to assist in the growing needs of the congregation. Some of the first parish families are pictured below with Fr. Ivo Plenković and Sister Maja Lovrić. Many have remained active members of the church board and youth groups. The church was later renamed Croatian Catholic Mission (CCM) Blessed Aloysius Stepinac. (Both courtesy CCM Blessed Aloysius Stepinac.)

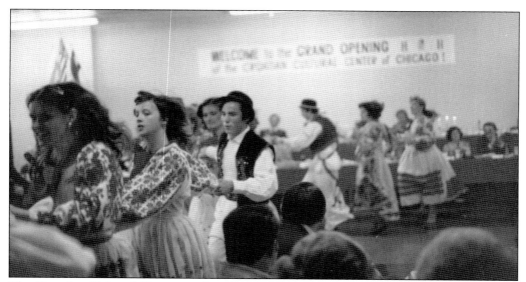

The Croatian Cultural Center on Devon Avenue opened in 1974. A committee headed by Dominican priests Fr. Hyacinth Eterović and Fr. Ivo Plenković and architect Vladimir Bašić converted a grocery store into what has since then become a main gathering place for the community. The center is located in the ethnically diverse Chicago neighborhood of West Rogers Park. Groups like the Hrvatska Foklorna Grupa (Croatian Folklore Group), pictured here, performed for the grand opening. (Courtesy Croatian Ethnic Institute.)

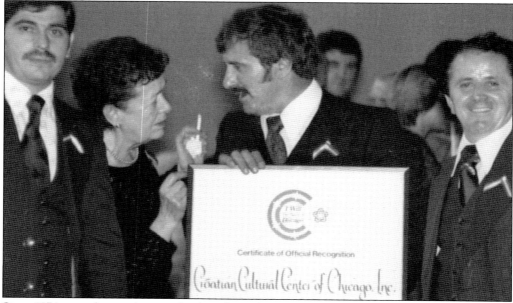

Since 1974, many have volunteered as board members to help organize events, manage the property, and balance the budget at the Croatian Cultural Center. The center has served as a location to host social, cultural, and political Croatian events. It is also the official base for the North Side Croatian-language school and the Hrvatska Loza (Croatian Vines) Tamburica Folklore Ensemble. Pictured here, past president Slavko Fumić holds a plaque alongside other members (from left to right) Joe Bašan, Branka Svačić, and Roko Štulac. (Courtesy Marija Fumić.)

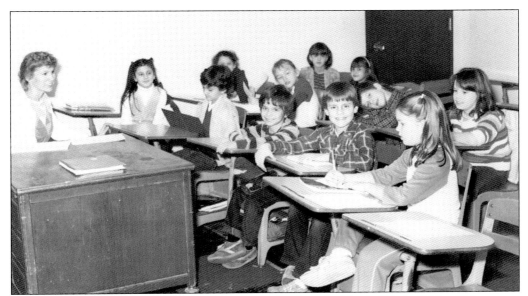

Fr. Ivo Plenković organized a Croatian-language school on the North Side in 1972 utilizing space in a nearby Protestant school on Lunt Avenue. In 1975, the Dominicans officially transferred the school to the Croatian Cultural Center. In addition to learning how to read and write, students were taught song and dance. Today the school continues with the same mission in mind, using textbooks and music to inspire young Croatian Americans. (Courtesy Fr. Nikola Dugandžić.)

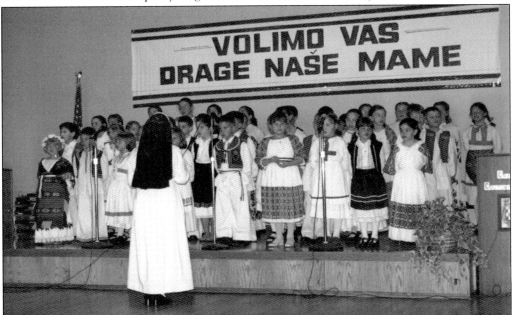

With the help of Dominican priests, nuns, parents, and other volunteers, Croatian-language dance and music class was taught weekly and continues to be taught today on the North Side. The annual highlights are performances for Christmas and Mother's Day, where students perform for their parents and other guests. "We Love you Dear Moms" is printed on the banner as the children recite special Mother's Day poems led by Sister Maja Lovrić. (Courtesy Fr. Nikola Dugandžić.)

Many immigrants who arrived after World War II were not proficient in English. To ease the language barriers and the cultural transition, they initially accepted jobs as janitors and maintenance workers. This offered opportunities to speak limited English and to learn new skills while becoming acclimated. It also was a great financial option for those with families since often the positions offered free living arrangements. Many, like Zvonko Vučić (right) and Zlatko Ranogajac (second from left), joined extracurricular clubs. (Courtesy Vida Vučić.)

Glas Hrvatske (The Voice of Croatia) began broadcasting on WOPA in Oak Park in 1959 and eventually transferred to WCEV. The program, sponsored by the Hrvatski Domobran (Croatian Guardians of Liberty) lasted until 1995. Many volunteers helped run the show over the years, including the late Franjo Mašić, pictured here, who hosted for more than eight years. (Courtesy Vladimir Novak.)

The City of Chicago held an official Bicentennial Pageant and Musical Salute to the American Flag at Soldier Field in June 1976. Along with other ethnic groups, Croatians both young and old participated. Children from the Croatian Folklore Group made the front page of the *Chicago Tribune*'s Tempo Section. Pictured from left to right are unidentified, Mara Karačić-Cooper, unidentified, Kathy Rudman, Silvija Pehar, Tommy Pavić, Johnny Rudman, and Ivica Vučičević. (Courtesy Vida Vučić.)

Parents and other members of the Croatian community also joined in the extravaganza, wearing costumes or traditional hand-knit blouses to identify their heritage. They participated at the bicentennial Soldier Field procession and joined the official salute to the many national flags flying on the edges of the stadium. Pictured here from left to right are Mara Vukušić, Luca Vučičević, Mrs. Ostojić, Mrs. Blagdan, Draga Kolar, and Marija Fumić. (Courtesy Croatian Ethnic Institute.)

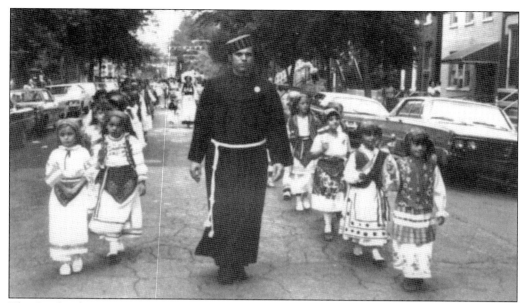

The Cardinal Stepinac Croatian School in Chicago was founded in January of 1973. About 40 students enrolled immediately. Annual tuition was $35 for one child. Fr. Ivan Bradvica, pictured here walking with students in the 1975 Velika Gospa procession, assumed the responsibility of organizing and running the Croatian School. Members of some of the early families who helped the priests organize the school included Ester Badrov, Ilinka Martinčić, Carol Marašović, Tončika Mišetić, Toni Pavela, Frida Penavić, Carol Plišić, Mary Rukavina, Jean Valenti, Sister Catherine Ann Mujić, and Duško Čondić. (Courtesy St. Jerome's Church.)

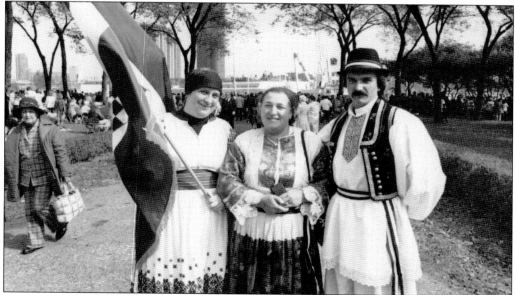

The Zrinski Frankopan folklore dance group formed in the 1970s with about 25 adult members. Like the others, they too participated in processions, parades, and concerts. Pictured here at the Grant Park City of Chicago Festival are members Mary Ellen Ratković (left), Vera Starčević (center), and John Markulin. (Courtesy Vera Starčević.)

Since 1961, Croatian groups have brought groups to sing, dance, and display ethnic heritage at the Museum of Science and Industry's Christmas Around the World event. Pictured on the front page of the *Weekly Reader's News Parade* in December 1976 are children from St. Jerome's Cardinal Stepinac Croatian School. Joining 34 countries, the group participated in the holiday festival. They helped decorate the Croatian exhibit and sang traditional Christmas songs for visitors. From left to right (first row) Tommy Hanson, Robin and Anita Martinčić, Sandy Plišić, (second row) Lynn and Lori Anne Marasović, Michelle Hanson, Nancy Plišić, Lana Marasović. (Courtesy St. Jerome's Church.)

With the help of Nada Hintermajer, the bimonthly magazine *Hrvatica* (Croatian Woman) was founded in Chicago in 1977. Similar to the American *Good Housekeeping*, the magazine featured current news events, activism, and feature articles for women. Among the early pioneers, editors, and contributors were Zlata Ivezić, Danica Glavaš, Ljiljana Zakarija, Lucija Jukić, Ikica Rosandić-Čuvalo, Mercedes Škegro, Zdravka Bušić, Ivanka Kuzmanović, Marijana Jelača, Vinka Pović, Lilian Simons, Marija Šopta, and Olga Ladika-Dizdar. (Courtesy Croatian Ethnic Institute.)

Michael Anthony Bilandić was born in 1923 to Croatian immigrants Mate and Dinka, who came to Chicago in the early 1900s and changed their name from Bilandžić to Bilandić. Michael and his three siblings grew up in Bridgeport and attended church and school at St. Jerome's. Bilandić finished De Salle High School and went on to St. Mary's College in Minnesota and De Paul University's College of Law. (Courtesy St. Jerome's Church.)

During World War II, Bilandić served as first lieutenant in the U.S. Marine Corps. He began practicing law in 1949 and was elected alderman of the 11th Ward in 1969, where he helped push forward protection for the city's environment, including a ban on lead-based paint and the passage of the Lakefront Protection Ordinance. He poses with fellow parishioners. From left to right are Mary Velcich-Miller, Eleanor Harzich-Bedalov, Mary Harzich-Pavela, Joanne Harzich-Pavela, Josephine Botica-Hanson, Bilandić, and Marie Valenti. (Courtesy St. Jerome's Church.)

Bilandić served as acting mayor of Chicago in 1976, replacing the late Mayor Richard J. Daley, until a special election voted him in officially. As mayor, he remained committed to enhancing the city and worked on providing affordable housing for residents. He also organized the first Chicago Fest and lent significant support to the first Chicago Marathon (and ran in it), both of which have become the roots of today's successful annual attractions. (Courtesy Croatian Ethnic Institute.)

Here Mayor Bilandić stops at the Navy Pier Folk Fair to pose at the Croatian booth. In 1978, he married Heather Morgan and soon after they had a son. After Bilandić was defeated by Jane Byrne in 1979, he returned to practicing law. In 1984, he was elected to the Illinois Appellate Court and later to the Illinois Supreme Court from 1990 until 2000, where he served as chief justice from 1994 to 1996. He died in 2002. (Courtesy Croatian Ethnic Institute.)

Bridgeport's annual Velika Gospa procession has always attracted neighborhood groups as well as local politicians. Dignitaries are issued formal sashes as they walk with the crowds. In the 1950s, as many as 100 lambs were put on the spits to accommodate the large crowds. Alderman Bilandić gives Mayor Richard J. Daley (pointing at the lamb) a behind-the-scenes tour of the meat roasting. (Courtesy St. Jerome's Church.)

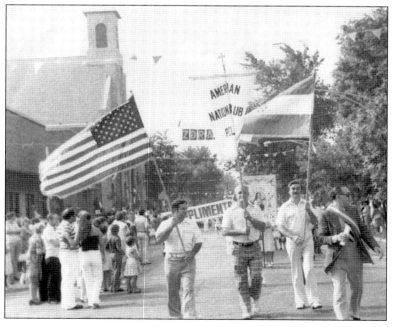

Croatian cultural groups, social organizations, church groups, high school marching bands, and war veterans begin the Holy Procession together, spiraling the streets around St. Jerome's. Carrying banners and flags, members of Club Poljica marching in the 1970s are, from left to right, Joe Grzetich, Tony Bozich, Mate Mihaljević, and Matt Šaškor. (Courtesy Eleanor Bozich-Grzetich.)

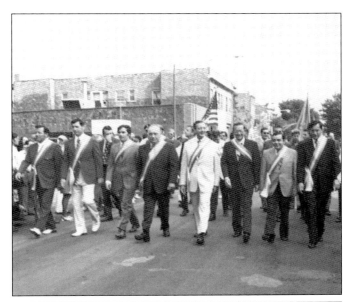

Edward "Eddie" Robert Vrdolyak was born in 1937 to Croatian immigrants. He is pictured here participating in a Velika Gospa procession along with, from left to right, two unidentified, then Senator Richard M. Daley, Mayor Richard J. Daley, Alderman Michael Bilandić, brother Victor Vrdolyak, Alderman Fred Roti, and Eddie. He was elected Democratic committeeman for Chicago's 10th Ward in 1968. He soon became alderman of the 10th Ward and served as president of the city council from 1977 to 1983. (Courtesy Croatian Ethnic Institute.)

In 1979, Vrdolyak managed Mayor Bilandić's reelection campaign. Bilandić lost to Jane Byrne, but Vrdolyak kept his aldermanic seat. He led the opposition in the city council to Mayor Harold Washington from 1983 to 1987, which eventually resulted in the political deadlock that came to be known as the "Council Wars." Joined by Michael Bilandić (left), Vrdolyak (right) poses with local Croatian architect Vladimir Walter Basich (center) and his wife, Elena Basich. (Courtesy Vladimir Walter Basich family.)

The annual soccer tournaments have grown in North America to include award banquets with formal dinners and dances, and a pageant also became part of the festivities in which a Kraljica Turnira (Queen of the Tournament) was selected each year. Young women, representing each soccer club, competed by presenting speeches in Croatian followed by questioning by the judges. Marianne (Renko) Kovačević (far left) and Mary (Tadijanović) Bušljeta (second from left) represented soccer clubs Jadran and Hrvat respectively. (Courtesy Ivan Dugandžić.)

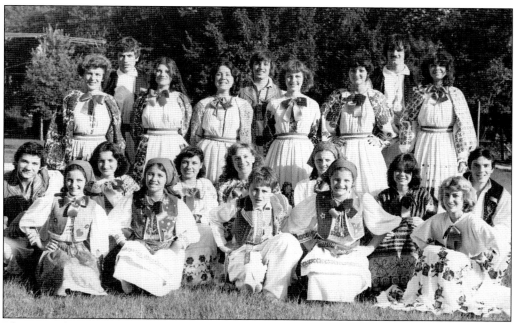

The Hrvatska Foklorna Grupa gather on Chicago's lakefront in 1979. From left to right are (first row) Antonia Miklaj, Željka (Sladin) Soštarić, John Vučičević, Rose (Miklaj) Renko, and Anna (Vučičević) Roženich; (second row) Ivo Perić, unidentified, Jasmina (Kadrić) Fitzgibbons, Olga Ladika-Dizdar, Višnja Miklaj, Jenny, and Steve Đapo; (third row) Anica Koščak, Rudi Puljić, Mirjana Tomašić, Slavica Ormuz, Branko Koščak, Kathy Rudman, Marica (Miklaj) Dickey, Veseljko Sladin, and Nada (Banić) Vasilj. (Courtesy Croatian Ethnic Institute.)

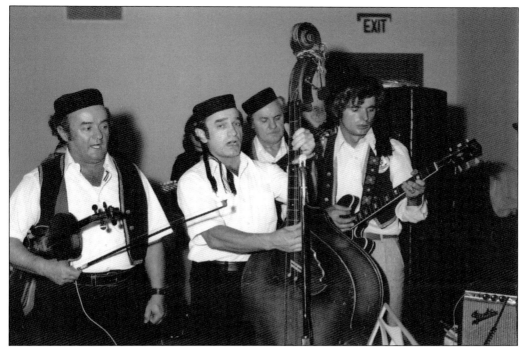

For decades, the group Velebit has entertained audiences with the sounds of Croatian folk music originating from the mountainous region of Lika in central Croatia. They began playing in the late 1960s and eventually dissolved by the mid-1990s. Pictured here in their signature lićke hats from left to right are Željko Starčević, Božo Prša, Milivoj Cindrić, and Radoslav "Frank" Gavran. (Courtesy Željko Starčević.)

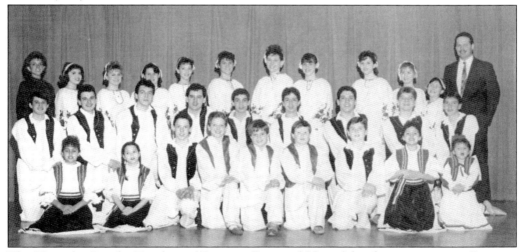

The Hrvatska Bratska Zajednica (Croatian Fraternal Union) has been preserving Croatian heritage by supporting tamburica groups and lodges throughout the United States and Canada. Since 1968, their famous annual festival in July is a chance for groups to highlight traditional songs and dances from the homeland. Pictured here is the Chicago Sloboda Junior Tamburitzans under the direction of Joe Kirin, a well-known brač player in the Chicago area who continues to entertain audiences. (Courtesy Croatian Fraternal Union.)

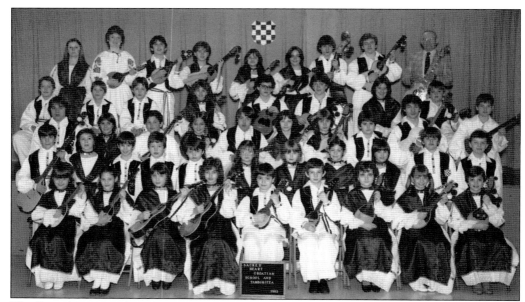

The Sacred Heart Kolo and Tamburica Group was founded in 1969 with the help of Kay Štimac, Rosemary Budeselich, Fr. Vendelin Vasilj, and instructors John Gornick and Edward Franciskovich. In 1972, the group celebrated the first tamburica Mass in Chicago. Joining the other parishes, the church also organized a Croatian School in 1974. Pictured is the 1983 group with instructor Roko Abramovich. (Courtesy Sacred Heart Kolo and Tambura Group.)

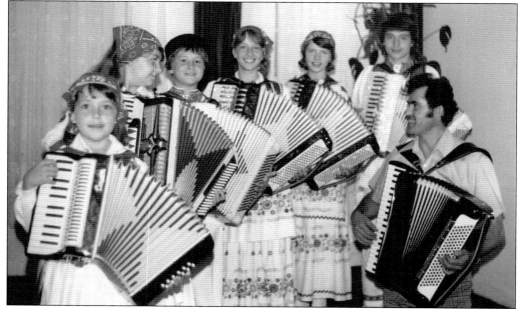

Instrument-playing is often a rite of passage for most children in the Croatian community. Whether learning to play the tambura or stroking the keys of an accordion, parents hope to pass on the trade secrets to their offspring. Instructor Mate Mulac stands with his group of students of Cardinal Stepinac Croatian School. From left to right are Marija Mulac, Vesna Mulac, Jure Rudman, Jadranka Žgela, Zrinka Mulc, and Vlado Mulc. (Courtesy Croatian Ethnic Institute.)

The Croatian Cultural Center had become a central gathering point, hosting political, religious, and social events and functioning as the main location to debut Croatian art and literature. The late Fr. Hrvoslav Ban was active in writing many plays, poems, and readings for Croatian youth. Pictured above with John Vučićević, Susan (Leko) Čuljak, and Monica (Grubišić) *Espinosa*, Father Ban hosts the official premiere of the Chicago-produced Croatian film *Zlatarevo Zlato*. (Courtesy Croatian Ethnic Institute.)

Bake sales, banquets, picnics, and rummage sales have offered great fund-raising opportunities for parishes and organizations. But, more importantly, they have offered great social bonding. Stories from the homeland, jokes, and a range of recipes are exchanged while fresh strudel dough is stretched out on a flat table. From left to right are Olga Soldo, Veselka Trogrančić, Ruža Grbavac, Sister Jelka Barišić, Ivanka Soče, Mandica Skukan, Marija Skukan, Vida Vučić, and Janja Hrvojević. (Courtesy Angel Guardian Mission.)

Dr. Ante Čuvalo arrived in the United States in the 1960s. Since then, he has dedicated a great deal of his time to researching and publishing various works on Croatians in Croatia and Bosnia-Herzegovina and the diaspora. Dr. Čuvalo has been a member of several local and national academic organizations. He has also been actively engaged in political developments in the homeland and authored several books and articles. Dr. Čuvalo is pictured here with his sister Iva Mišetić at the 16th anniversary banquet of the Croatian American Association. (Courtesy Ivan Mlinarich.)

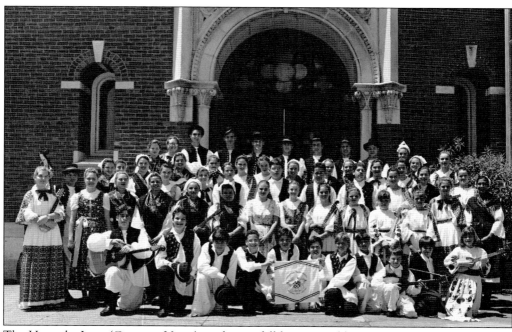

The Hrvatska Loza (Croatian Vines) tamburica folklore ensemble was established on the North Side in 1979. The group includes young parishioners of the CCM Blessed Aloysius Stepinac (formerly the Angel Guardian Mission) and students from Hrvatska Škola (Croatian School) of the Croatian Cultural Center. The first teachers and founders were Jedinko Prskalo and Vera Starčević. Pictured here in front of church are the performing and junior groups in the early 1990s. (Courtesy Hrvatska Loza.)

Four

A NEW ERA OF INDEPENDENCE

The end of the Cold War ushered in a new chapter for the history books. The shift in global politics and the fall of the Berlin Wall gave many Croatians a renewed sense of spirit to act upon their long-yearned-for independence from Yugoslavia. In the early 1990s, the new Republics of Croatia and Bosnia-Herzegovina were declared. The ripple effect was a Communist-free Eastern Europe. This, however, sparked a long, bitter war in the region with many civilian casualties and damage to infrastructures and homesteads. Croatian American radio shows expanded their programs to inform listeners and to raise awareness, and families gathered around shortwave radios to hear updates from the war front. This era spurred yet another migratory wave of new families and faces to the Chicago area in the early 1990s.

As a key hub for political, cultural, religious, and social organizations, the Chicago diaspora played an important role in the independence movement and the eventual declaration of the new Republics of Croatia and Bosnia Herzegovina respectively. Many young professionals left for Washington D.C. and overseas to offer their services. Collectively the Chicago-based organizations led national efforts in sending financial and humanitarian aid to these new countries. Youth groups created a Chicago Croatians web site and worked to lobby elected officials and create English-language awareness campaigns. A Croatian consulate opened in Chicago to service the Midwest region.

For many Croatian Americans, this new era of independence renewed the sense of kinship and community. Croatian athletes joined the ranks of the Chicago Bulls and the Chicago Bears, giving an outlet for the diaspora to display national pride at a time when ethnic identity was reborn. The 1996 Summer Olympics stirred up emotions as proud Croatian Americans watched a Croatian flag fly alongside other nations for the first time on American soil. Restaurants and cafes like Café Continental, Café Croatia, the Jovial Club, and others saw an increase in clientele. Local bands like Croatia Combo, Veseli Kordunaši, Nova Moda, Plavi Jadran, Mlada Generacija, Plava Laguna, Ludi Ritam, Boduli, Vatra, Slanina, Bravo Band Chicago, Majstori, Sinovi, Srdjan and Mario, and many others spent years entertaining Croatian audiences. Now they collectively took part in having reinvigorated this community. Annual folklore festivals experienced a surge in attendance as lyrics and dances performed over the many years suddenly came to life and had new meaning.

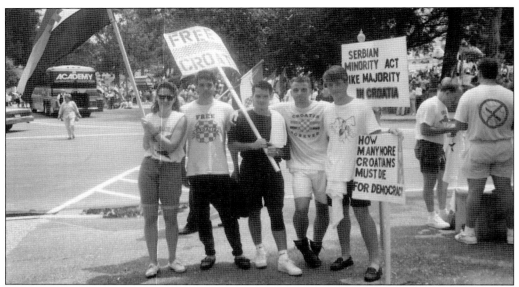

Members of the Hrvatska Mladež group (Croatian Youth) moved quickly to organize themselves at the onset of the conflict in Croatia and Bosnia-Herzegovina. They arranged calling campaigns, demonstrations, fund-raising events, lobbied elected officials, and helped open a press office at the Croatian Cultural Center. Some went overseas to offer services. Others traveled to Washington D.C. to put pressure on Congress. From left to right are Jackie Prkić, Mark Barišić, Frank Hrvojević, John Rukavina, and Ivo Puljić. (Courtesy Kata Vučić.)

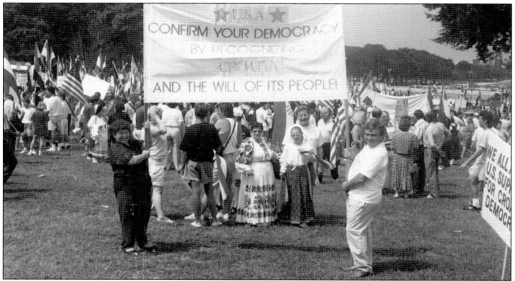

Croatians of all ages came together to lobby elected U.S. officials to step in and help during the wars of aggression in Croatia and Bosnia-Herzegovina. Special committees and meetings with various cross-cultural organizations were initiated in Chicago in an effort to galvanize the community and offer insight to non-Croatian audiences. Others traveled to Washington D.C. Marica and Zlatko Pavlaković are pictured here holding a banner during a lobbying rally in the capital. Rezika and Josip Miklaj stand in the center with their daughter wearing Croatian costumes. (Courtesy Fr. Nikola Dugandžić.)

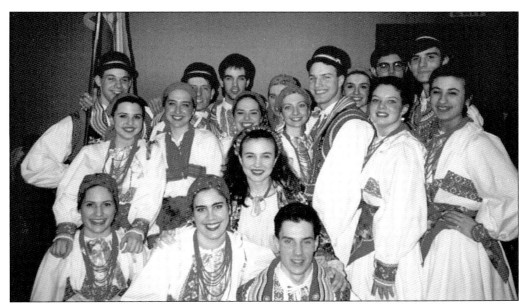

When the conflicts began in Croatia in the 1990s, many students became activists. The first Croatian Students Club of Loyola University organized for the campus cultural fest in 1993. Pictured are, from left to right, (first row) Maria Dugandžić-Pašić, Jadranka Dugandžić, Antonia Madunić, and Steve Mihaljević; (second row) Marijana (Duševic) Stavlić, Antonia (Runac) Hayes, Marija Pavić, Kata Vučić, Mijo Vodopić, Ana (Braovac) Hrvojević, and Maria (Fumić) Skukan; (third row) unidentified, Ivo Puljić, John Badrov, Ksenija Leko, Snježana (Mulac) Šego, Steve Brajković, and Ivan Planinić. (Author's collection.)

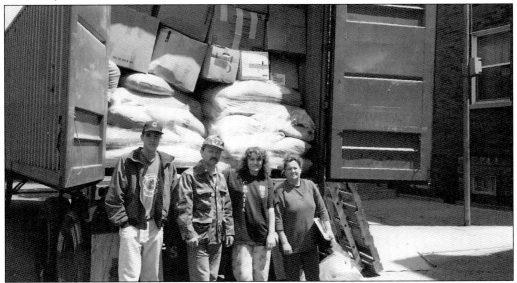

As international audiences watched the destruction of Vukovar and the medieval walls of Dubrovnik, Croatian community groups joined efforts to donate goods and to ship containers of supplies to the war front. According to Hrvatska Žena, over 300 containers were sent, valued at over $10 million. Pictured in front of a container from left to right are Mario Jurković, Ivica Trutin, Nevenka Jurković, and Milica Trutin. (Courtesy Hrvatska Žena.)

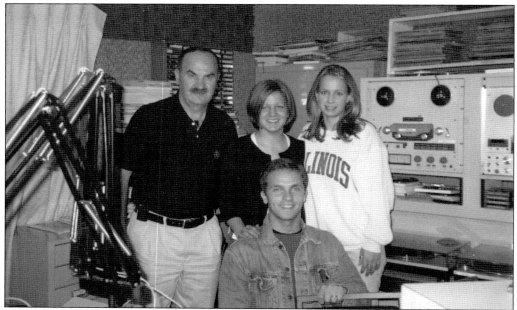

During the conflicts in Croatia and Bosnia-Herzegovina, the Croatian-language radio programs were vital to the community. Young Croatians offered their time and expertise to provide more content. Radio Free Croatia's half-hour program, *Novi Zvuk* (New Sound), was created to attract younger listeners, featuring top-10 music hits in Croatia, social highlights in the Chicago area, and young radio guests from Croatia. From left to right are Ilija Pavljašević, Vesna (Lončar) Marušić, Tomislav Škarica (seated), and Silvija (Mihaljević) Sajković. (Courtesy Kata Vučić.)

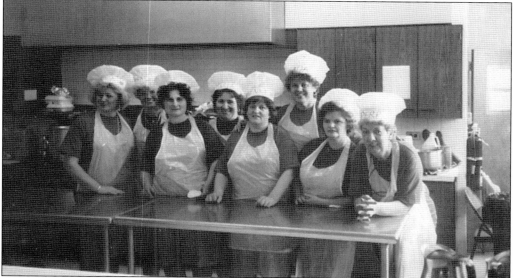

As the conflict spread, parishes and organizations continued to host fund-raisers to help those in need. Parishioners of Sacred Heart Church organized a benefit for wounded Croatian soldiers. Volunteers donated their time and cooking skills to raise funds. From left to right are Danica Protega, Mary Maras, Vilka Ilić, Marija Sopčić, Nevenka Soldo, Nada Šegić, Marica Sopčić, and Perpie Budeselich. (Courtesy Slavko and Vilka Ilić.)

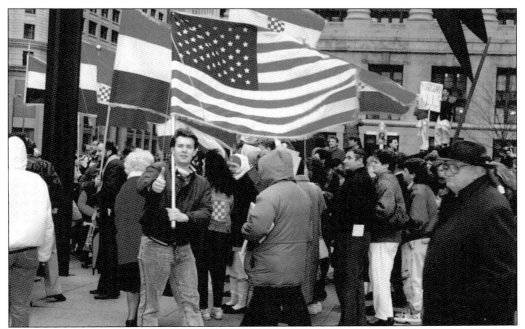

Public awareness and lobbying became a weekly duty during the height of the conflict. Groups marched onto Daley Plaza with flags and banners to pressure local officials. Pictured here is John Crnkovich, longtime tambura instructor for Sacred Heart Tambura and Kolo Group. (Courtesy Angel Guardian Mission.)

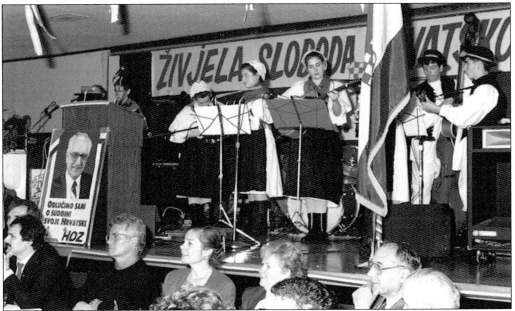

The Hrvatska Demokratska Zajednica (Croatian Democratic Union) party ruled Croatia exclusively in the first 10 years of the new republic's existence. The party enjoyed tremendous financial and voter support from the diaspora. Banquets and fund-raisers were frequent, as were guest speakers brought in from Croatia to update expatriate constituents. (Courtesy Angel Guardian Mission.)

Based in Hobart, Indiana, the Hrvatska Katolička Zajednica (Croatian Catholic Union or CCU) played a major role in supporting the promotion of the Croatian Catholic faith and its heritage. The organization's newspaper, *Naša Nada* (Our Hope), has informed members since the 1920s. During the move for Croatian independence, the CCU was active in fund-raising efforts and lobbying campaigns. In 2006, the CCU merged with the Croatian Fraternal Union. (Courtesy Angel Guardian Mission.)

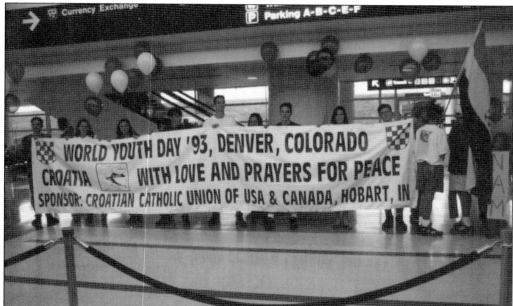

Pope John Paul II announced a World Youth Day in Denver, Colorado, in 1993. The Croatian Catholic Union sponsored a group of young Croatians and clergy to the United States. Along with other Chicagoans, the group traveled to Denver to proudly represent Croatia in its first World Youth Day as a new nation. (Courtesy Angel Guardian Mission.)

Croatian Ivan "John" Jurković played 10 NFL seasons for Green Bay, Jacksonville, and Cleveland. His brother, Mirko Jurković, played for the University of Notre Dame and one season with the Chicago Bears. Here John (left) and Mirko take time out during a practice in Green Bay in 1994. John "Jurko" is now an afternoon host on the ESPN Radio 1000-AM *Mac, Jurko, and Harry Show*. (Courtesy Ivan and Mirko Jurković.)

Vidak and Zlata Jurković left Herzegovina in the early 1960s for Germany and married in 1965. In 1967, the family arrived in South Chicago. Vidak worked as a tool and die maker, while Zlata worked at the Ford Motor Company in Chicago Heights. After years of watching their sons play football, they now stay busy attending their grandchildren's activities. From left to right are (first row) Samantha, Grace, Baka Zlata, Luka, and Dida Vidak; (second row) Max, Jake, Mirko Jr., Savanna, Niko, and Clare. (Courtesy Vidak Jurković.)

Professional basketball player Toni Kukoč became the first Croatian to be drafted to the NBA's Chicago Bulls. For seven years, Croatian Americans rallied behind the 6-foot, 11-inch sensation from Split, Croatia. During the height of his Bulls career, Kukoč was third on the team in scoring behind Michael Jordan and Scottie Pippen. He retired from professional basketball in 2006. Kukoč poses with Chicagoans Antonija Tonćika Mišetić (left) and Marija Knezović. (Courtesy Nevenka Jurković.)

Born in Chicago, Chris Robert Zorich was raised by his Croatian mother, Zora, on Chicago's South Side. He enjoyed a successful college career at the University of Notre Dame and in 1991 was drafted by the Chicago Bears. After one season with the Washington Redskins, he returned to Notre Dame to earn his law degree. He accepted a position at Notre Dame's athletic department in 2008. In 1993, he established the Christopher Zorich Foundation to honor his late mother. (Courtesy Jadranka Rukavina.)

Anthony J. Peraica was born in Croatia in 1957. Orphaned at 11, he came to Chicago at 13 to live with his aunt and uncle in Bridgeport. He began his legal career as an attorney, eventually opening up his own private practice. He has served on the Cook County Board of Commissioners since 2002 and currently represents the 16th District. During the war, he was a key leader of the lobbying group the Croatian American Association (CAA). Pictured here with guest speaker Cook County treasurer Maria Pappas, Peraica emcees the CAA event. (Courtesy Ivan Mlinarich.)

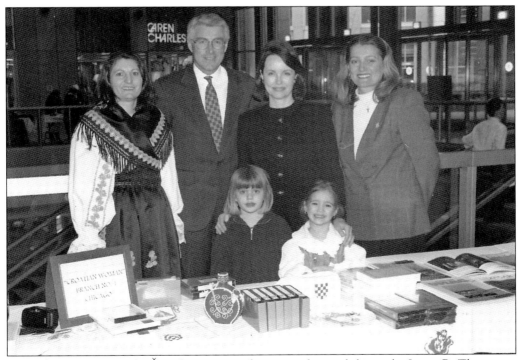

Since the 1990s, Hrvatska Žena has organized an annual art exhibit at the James R. Thompson Center in Chicago, featuring art and literary works by Croatian artists. From left to right are (first row) Anita Kosir and Antonia Jurković; (second row) Stoja Kosir, Gov. Jim Edgar, First Lady Brenda Edgar, and Nevenka Jurković. (Courtesy Hrvatska Žena.)

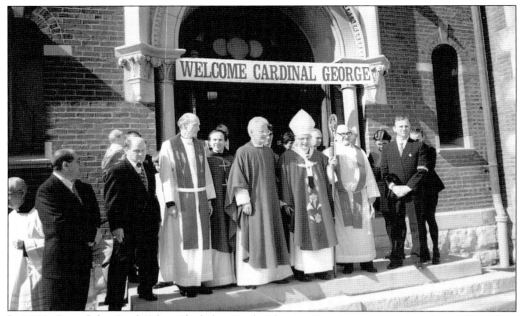

In 1998, Pope John Paul II beatified the Card. Aloysius Stepinac, prompting Angel Guardian Mission to change its name to Croatian Catholic Mission Blessed Aloysius Stepinac. The event was celebrated with a Holy Mass officiated by Francis Cardinal George of Chicago. From left to right are Miško Primorac, Nikola Hrvojević, unidentified, Fr. Ljubo Krasić, Fr. Nikola Dugandžić, Francis Cardinal George, Fr. Častimir Majić, and Slavko Grbavac. The church has since been transferred to the Croatian Franciscan Custody under the direction of Fr. Ivica Majstorović (Courtesy CCM Blessed Aloysius Stepinac.)

A 1982 graduate of DePaul University College of Law, Judge Marcia Maras has served as Cook County Circuit Court judge since 1999. Previously she was chief deputy of the Cook County Assessor's Office, assistant general counsel in the Assessor's Office, and an assistant state's attorney in the Real Estate Tax Unit. Sitting next to her mother, Marie Lončar-Maras (front left), Judge Maras (front right) poses with her siblings, nieces, and nephews. (Courtesy Marie Lončar-Maras.)

Pat Michalski has been a longtime supporter of the Croatian Community. As head of multicultural affairs for the Cook County Treasurer's Office, she has worked to provide exposure to the melting pot of nations in the city of Chicago. Attending a summer picnic on the North Side, Michalski spends time with parishioners. Pictured are, from left to right, Veselka Trogrančić, Pat Michalski, Zdravka Obradović, and Vera Starčević. (Courtesy Blessed Aloysius Stepinac Mission.)

Brenda Brkušić spent 18 years in Chicago before moving to Los Angeles. At the age of 22, she produced and directed an award-winning, feature-length PBS TV documentary, Freedom from Despair, that tells true stories of the Croatian struggle to overcome oppression in Yugoslavia and the ensuing fight for independence in the 1990s. Brkušić is a producer and channel manager for PBS TV. She hosted a cooking show featuring Croatian cuisine and is producing a documentary about Croatian ballerina Mia Slavenska. (Courtesy Istina Productions.)

In 1999, the first consulate of the Republic of Croatia was officially opened in Chicago. The early years were busy for all the new government locations. Bringing the new nation to the forefront of awareness both on a local and national level was crucial. Pictured here, the first consulate general, Domagoj Šola, sits at the Michigan Avenue office with Zrinka Dugandžić. (Courtesy Domagoj Šola.)

Croatians abroad have long enjoyed organizing world tours for top bands and singers from Croatia and Bosnia-Herzegovina. Chicago has always been a major performance stop for these celebrities. In 1999, one of Croatia's cultural icons and top artists, Oliver Dragojević, sang at the Hyatt Hotel for the official reception celebrating the opening of the Croatian consulate in Chicago. Fans Silvija (Mihaljević) Sajković (left) and Kata Vučić (right) stand next to the Croatian star. (Courtesy Kata Vučić.)

Five

CROATIANS TODAY

The balancing act of being an American while preserving Croatian roots has proven challenging for many. Suburban sprawl, greater American assimilation, and a busier lifestyle have altered the ethnic nucleus. Old traditions and philosophies have gradually been replaced with more modern, progressive ones. Despite these challenges, the community has worked hard to retain the building blocks of their forefathers.

As the demographic of Chicago's ethnic neighborhoods has changed, the clergy have made great efforts to keep Sacred Heart, St. Jerome's, the Croatian Catholic Mission Blessed Aloysius Stepinac, and Holy Trinity functional. The Franciscan Holy Family has also been crucial in uniting the communities of Joliet and northern Indiana. As they did in the 1900s, Croatian-language masses, summer picnics, concerts, and religious outings remain a crucial mission for the religious leaders of the community.

Croatian-language schools continue to enroll new students annually as parents and volunteers work together to adapt teaching styles to conform to today's student. Much like Spanglish overtook the various Spanish dialects in the United States, new variations of Croatian vocabulary have emerged globally, prompting new textbooks to be published for the Croatian diaspora in English, Croatian, French, and German.

It is estimated that over 150,000 people of Croatian ancestry now reside in the greater Chicagoland area. Many continue to fraternize as the early settlers did through community events around the same parishes and social halls, while others have found new networking paths. Social media has helped the younger generation stay in touch through web sites such as the Chicago Croatians Facebook page. Recreational groups like the Bočarski Klub (Bocci Club) and the old-timer soccer clubs of Leteći Anđeli and Hrvat meet regularly in the spring and summer months. Hunting Clubs Kuna and Srna draw large crowds to their annual culinary feasts on their respective North and South Sides of Chicago. Several folklore groups continue to attract a diverse age group as they host annual concerts and travel to Croatia for festivals, while the existence of the folklore group Hrvatska Baština allows adults a chance to continue their passion for song and dance long after they've left these junior groups. In essence, today's Croatian American has continuous options to tap into the community spiritually, politically, culturally, or socially.

Chicago and its melting pot of nations have encouraged ethnic preservation, but more importantly, the city has offered outlets for expression. Croatian cultural, religious, and social groups continue to participate in official exhibitions, parades, rallies, tournaments, and concerts throughout the city. It is the hope that these foundations will pave the way for new legacies and stories to be told for generations to come.

Croatian-American Day is celebrated annually in Chicago's Daley Plaza with a flag-raising, the singing of the anthems, and performances by Croatian folklore groups and other musicians to entertain the public. From left to right, volunteers Snježana Šego, Ruža Šumera, Mara Romanović, and a visiting relative staff several tents on the plaza, featuring work by local Croatian artists, tourism information, and novelties. (Courtesy Ivan Mlinarich.)

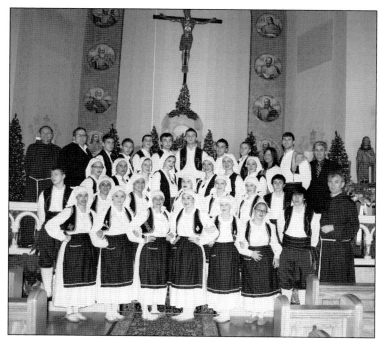

Club Stepinac has had a kolo dance troupe and a tambura orchestra since 1988. The club's aim, like the other parishes, is to gather graduates of Croatian School in an effort to foster and preserve their ties to the community and St. Jerome's Church. Like other folklore groups, many volunteers have spent countless hours sewing the group's folk costumes. Tambura teacher Joe Cvitković has taught for more than 20 years. (Courtesy Club Stepinac Kolo and Tambura Group.)

For the past century, faith has remained a central anchor for the Croatian community. Many of the older church-sponsored groups have managed to survive like Club Cres, Club Zadar, Club Sinj, Club Poljica, Holy Name Society, St. Jerome's Post and Auxiliary No. 595, and others. Parishes collectively organize annual pilgrimages to holy sites such as Međugorje and Holy Hill Basilica in Wisconsin. Members of Marijino Društvo (the Marion Society) pose here at a group outing. (Courtesy Ivan Mlinarich.)

The annual feast of St. Anthony is still celebrated at the grounds of the Croatian Franciscan Custody. Worshippers and clergy from the Chicagoland parishes come together to celebrate an outdoor Mass and later enjoy a picnic on the sprawling grounds of the Croatian Franciscan Custody. (Courtesy Croatian Ethnic Institute.)

Even in a friendly game, the rules of bocci can become very intense. Recreational teams like the Bočarski Klub Croatia meet regularly on Montrose and Lincoln Avenues to test their skills. Other bocci fans, like the ones seen here, team up at picnics for a casual game and a chance to stretch their muscles. (Courtesy Ivan Mlinarich.)

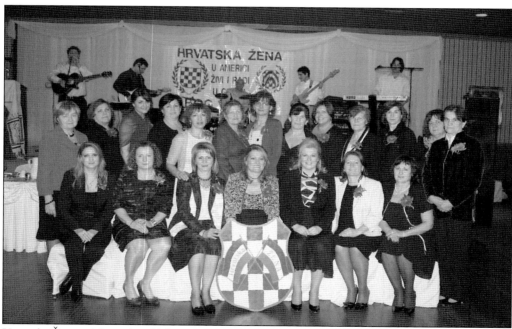

Hrvatska Žena celebrated its 80th anniversary in 2009. It is one of the oldest organizations still active in Chicago. From left to right are (front row) Renee Pea (acting consul general of Croatia), Miljenka Crnjač, Fanika Janko, Nevenka Jurković, Kolinda Grabar Kitarović (Croatian ambassador to the United States), Stojka Kosir, and Vesna Mlinarich; (second row) Katica Kosić, Kate Mulac, Snježana Šego, Olga Puljić, Nevenka Gasparić, Ruža Šumera, Smilja Tosić, Iva Jakelja, Janice Subašić, Mila Grubišić, Marija Lisnić, Ankica Lončar, and Ana Vučić. (Courtesy Hrvatska Žena.)

Club Poljica is known for its annual Bakalar dinner at St. Jerome's, complete with entertainment and dancing. Bakalar is a stew of dried cod and potatoes, traditionally served with the Christmas meal in Dalmatian households. According to legend, it was introduced to Croatians after Dalmatian sailors returned from trips on the North Atlantic and has been imported ever since. Shown here, the folklore group Hrvatska Baština performs at a recent Bakalar dinner. (Courtesy Ivan Mlinarich.)

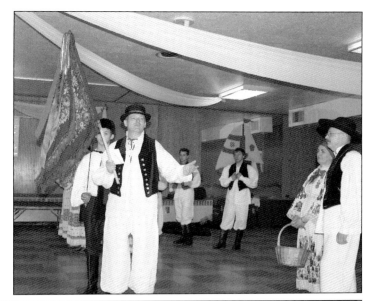

Multiple generations have celebrated special occasions at the Croatian Cultural Center. The venue offers guests traditional home-cooked dishes and an ethnic atmosphere. In 2009, the center celebrated its 35th anniversary. Some of its members over the years are pictured here. From left to right are (first row) unidentified, Val Vujica, Mara (Karačić) Cooper, Željko Kraljević, and Marija Fumić; (second row) Mandica Skukan, Ivana (Hrvojević) Mihalić, Ksenija (Ziman) Hrvojević, Laura Tomačić, Mary (Bašan) Kraljević, Chrissy (Puljić) Vasilj, and Đela Toromanović. (Courtesy Ivan Mlinarich.)

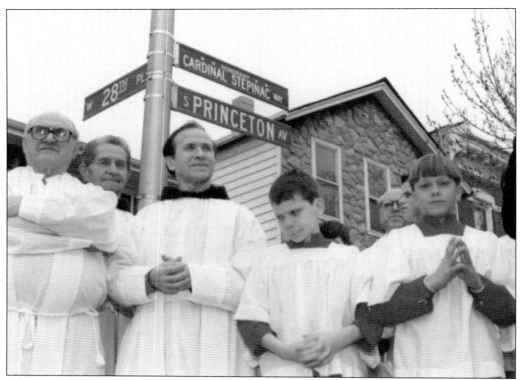

After Pope John Paul II beatified Card. Aloysius Stepinac in 1998, Mayor Richard M. Daley proclaimed an official Cardinal Stepinac Day and later granted an official street dedication for Cardinal Stepinac Way on Princeton Avenue in 1999. From left to right, Franciscan priests Fr. Častimir Majić, Fr. Bruno Raspudić, and Fr. Ljubo Krasić, along with altar boys from St. Jerome's, stand at the corner of Princeton Avenue and Twenty-eighth Street to enjoy the crowded streets for the 2002 centennial church celebration. (Courtesy St. Jerome's Church.)

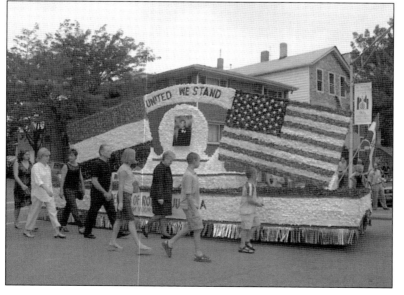

As is customary in the annual Velika Gospa procession, large floats in honor of religious figures, church groups, organizations, or parish families have lined the streets of Bridgeport. Parishioners here march alongside a float supporting the War on Terror after the September 11, 2001, attacks on the United States. (Courtesy St. Jerome's Church.)

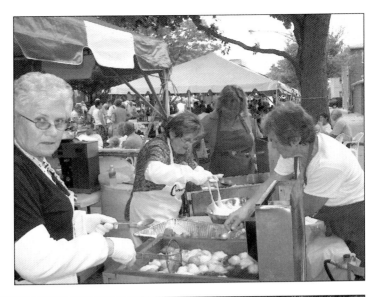

Bridgeport festivals continue to draw big crowds. Every year, volunteers roll up their sleeves to help prepare the special meats, side dishes, and pastries. These women prepare traditional Dalmatian *fritule*, a dough pastry fried in hot oil and served with powdered sugar. In 2009, more than 325 pounds of flour was used to make the fritule. From left to right are Ankica Došen, Anđa Novak, unidentified, and Nevenka Mulc. (Courtesy Marinko Goravica.)

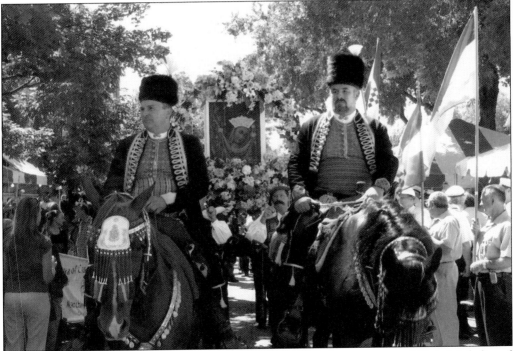

The annual celebration of Velika Gospa originated in the Dalmatian town of Sinj. It is believed that the Sinjska Gospa (Our Lady of Sinj) saved the town from Turkish conquest in 1715. On August 14, residents gathered to pray for help before a portrait of the Virgin Mary. The next day, an apparition appeared to the townspeople, and shortly after the Turkish soldiers became ill and retreated. This withdrawal is attributed to the Blessed Mother's help and is honored annually. Traditionally the horsemen of Sinj, the Sinjski Alkari, kick off the procession on horseback in Croatia. In 2006, the Sinjski Alkari came from Croatia to participate in St. Jerome's procession. (Courtesy St. Jerome's Church.)

Soccer remains the preferred organized sport for the community. The HNK Zrinski Soccer Club, formed in 1993, still plays in the Metropolitan League and has expanded to include a third generation of little athletes, under 8 and under 12. Pictured is an early Zrinski soccer team. From left to right are (first row) Stanko Batinić, Ivo Puljić, Frankie Hrvojević, Mladen Jukić, Johnny Rukavina, Boris Kuzmanović, and Nikola Madjer; (second row) Ante Bušljeta, Zdenko Čuljak, Mario Soldo, Mark Barišić, Dominik Dugandžić, Andjelko Čigir, John Pervan, Ivo Vasilj, and coach Anto Budimir. (Courtesy Ante Bušljeta.)

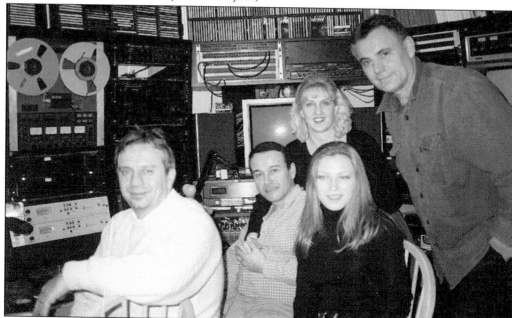

Hrvatsko-Američki Radio Klub remains the longest-running program in Chicago. Radio Slobodna Hrvatska (Radio Free Croatia) began its broadcast in 1976. Longtime hosts Ivica (second from left) and Tina Metzger (arm over the shoulder of Ivica) entertain listeners every Saturday afternoon on WNDZ 750-AM. In 1998, St. Jerome's Church organized a new religious program, Hrvatski Katolički Radio (Croatian Catholic Radio), representing Chicagoland Croatian parishes every Saturday morning also on WNDZ from 10:00 a.m. to 11:00 a.m. (Courtesy Radio Free Croatia.)

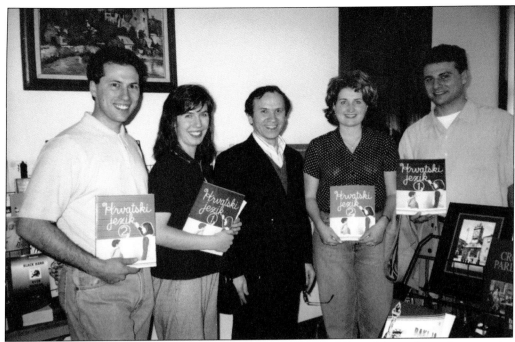

Established in 1974, HIŠAK (Croatian Schools of America and Canada) was formed to organize Croatian language schools and teacher-training seminars across North America. The organization publishes manuals and teaching tools catered specifically to the learning needs of the diaspora. Currently, 30 schools are active members. Croatian school alumni hold new versions of the school textbooks at the Croatian Ethnic Institute bookstore. Picture are, from left to right, John Barun, Ana (Bagarić) Barun, Fr. Ljubo Krasić, Ann Marie (Lisnić) Draženović, and Ljubo Draženović. (Courtesy Croatian Ethnic Institute.)

Zorica Matković served as the second consul general of the Republic of Croatia in Chicago from 2004 through 2008. She helped boost tremendous awareness of Croatian arts in the Chicago area. At right, Matković attends a performance at the University of Chicago featuring the "dynamic duo of Dubrovnik," longtime friends and world-class musicians Mario and Srdjan. From left to right are Janja Sedej-Jurković, Renee Pea, Srdjan Givoje, Zorica Matković (consul general of Croatia in Chicago), Neven Jurica (Croatian ambassador to the United States), Mario Romanović, Fr. Ivica Majstorović, and Fr. Jozo Grbeš. (Courtesy St. Jerome's Church.)

Dalibor Bagarić played for the Chicago Bulls from 2000 to 2003. With Toni Kukoč gone, proud fans rallied behind the second Croatian Bulls member. In his first year with the team, a Croatian Night was organized at the United Center when the Bulls and Bagarić went up against Kukoč, who was with the Milwaukee Bucks at the time. Pictured here with his wife, Jasmina, and two daughters, Bagarić attended Mass and other events in the Croatian community. He now plays in Europe. (Courtesy Dalibor Bagarić Family.)

Bill Kurtis, born William Horton Kuretich, is a second-generation Croatian American with roots near Zagreb. In the 1970s and 1980s, he anchored for WBBM's newscast with Walter Jacobson. He left to anchor CBS *Morning News* in New York but returned to Chicago and founded Kurtis Productions, which has produced several award-winning television series and documentaries. In 1999, Kurtis was the official emcee for a banquet celebrating the opening of the first consulate of the Republic of Croatia in Chicago. (Courtesy Kurtis Productions.)

Mary Matalin grew up in Calumet City. Her paternal grandparents met on the boat from Croatia. Matalin has been active in politics since her college days and credits her father, Steve, for giving her the passion. She has served as assistant to Pres. George W. Bush and counselor to Vice Pres. Dick Cheney. She is currently a CNN political contributor and her books have made it on various best-seller lists. Married to Democratic political consultant James Carville, the couple lives in Virginia with their two daughters. (Courtesy Mary Matalin.)

David Diehl grew up in Chicago. The Bekavac family, on his mother's side, originated from the southern Croatian coast. David was drafted by the NFL's New York Giants in 2003 and became the first Giants rookie since 1985 to start every game in his first five years with the pro team. Best friends with Tom Pavljašević since eighth grade, David poses on the field with Peter Čabo (right) and Pavljašević after his team won the 2008 Super Bowl. He has a signature tattoo on his left arm displaying the old Croatian coat of arms. (Courtesy Tom Pavljašević.)

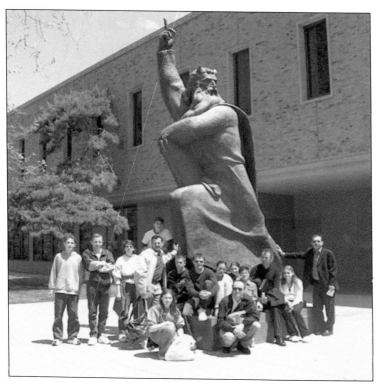

To better understand the contributions of Croatians in America, field trips are organized to visit the University of Notre Dame and view the numerous works by Croatian artist Ivan Meštrović. The university's museum recently built a gallery to feature his works. Students and teachers of Croatian school Kardinal Stepinac pose next the 18-foot bronze *Statue of Moses* sculpted by another noted Croatian artist, Josip Turkalj. Turkalj worked as an assistant with Meštrović at Notre Dame. (Courtesy Ivan Mlinarich.)

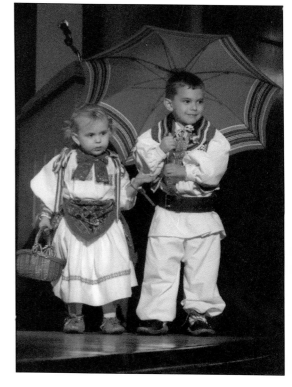

Over 170 years have passed since the first Croatians stepped foot in the "City of Big Shoulders." Since then, generations have inherited the duty to preserve and pass on the Croatian heritage and the many stories that intertwine its long history. It is the hope that the next wave of young ones, like siblings Lana (left) and Filip (right) Živko will remember, will remember the legacies, songs, and dances for future generations to come. (Courtesy Nicole Vurušić.)

BIBLIOGRAPHY

Balch, Emily. *Our Fellow Slavic Citizens*. New York: Charities Publication Committee, 1910.
Chicago Daily Tribune. Chicago: July 21, 1953.
Centennial, the Life and Work of the Croatian People in Chicagoland. Chicago: Croatian Franciscan Press, 1949.
Čizmić, Ivan. *History of the Croatian Fraternal Union of America 1894–1994*. Zagreb, Croatia: Golden Marketing, 1994.
Croatian Almanac: Outstanding American and Canadian Croats. Chicago: Croatian Franciscan Press, 2000.
Crnković, Rudolf. *Sa "Zvonomirom" po Americi, Zapisci 5 Godišnjeg Tamburaškog Putovanja*. Chicago: 1933.
Duis, Perry R. *The Saloon: Public Drinking in Chicago and Boston, 1880–1920*. Champaign, IL: University of Illinois Press, 1983.
Jolić, Fr. Robert and Fr. Jozo Grbeš. *A Century of Fidelity*. Chicago: Croatian Franciscan Press, 2000.
Krasić, Ljubo. *Croats in Chicago*. Chicago, 2009.
Meler, Vjekoslav. *Hrvati u Americi, Hrvatske Kolonije u Chicagu i St. Louisu*. Chicago: Adria Printing, 1927.
Memorial Book of World War II, Sacred Heart Croatian Church. Chicago: 1946.
Montgomery, David. *Labor in the Industrial Era*. United States Department of Labor, 1996.

Discover Thousands of Local History Books
Featuring Millions of Vintage Images

Arcadia Publishing, the leading local history publisher in the United States, is committed to making history accessible and meaningful through publishing books that celebrate and preserve the heritage of America's people and places.

Find more books like this at
www.arcadiapublishing.com

Search for your hometown history, your old stomping grounds, and even your favorite sports team.

Consistent with our mission to preserve history on a local level, this book was printed in South Carolina on American-made paper and manufactured entirely in the United States. Products carrying the accredited Forest Stewardship Council (FSC) label are printed on 100 percent FSC-certified paper.